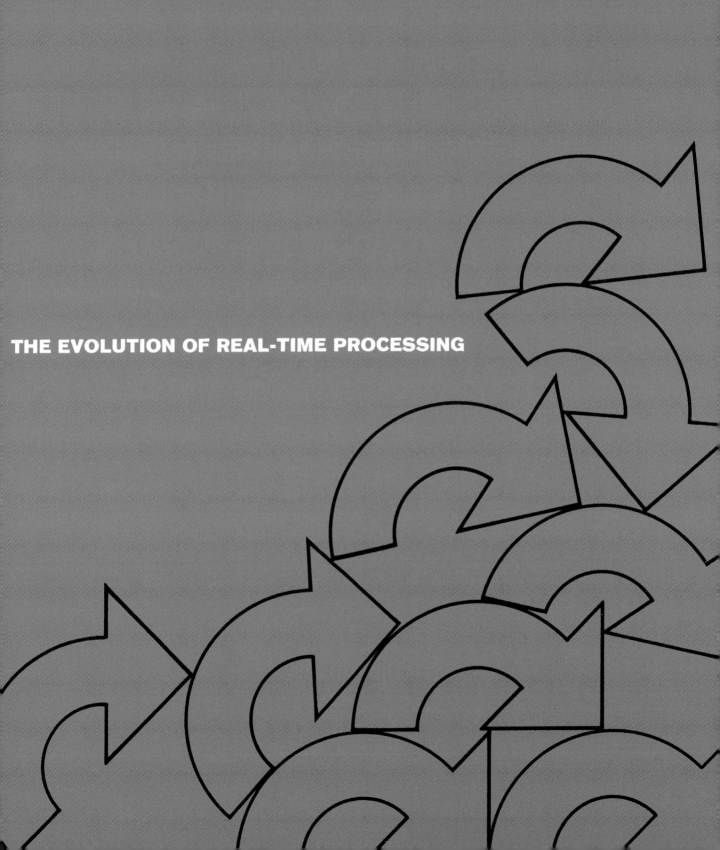

THE EVOLUTION OF REAL-TIME PROCESSING

DO YOU COMPUTE?

SELLING TECH FROM THE ATOMIC AGE TO THE Y2K BUG 1950–1999

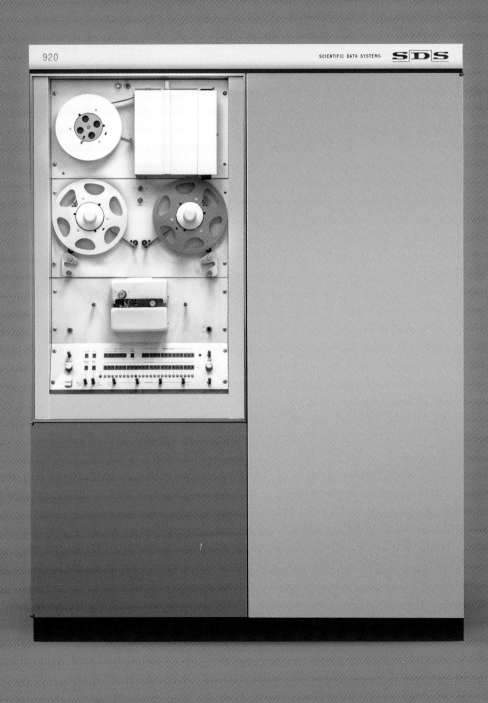

TABLE OF
CONTENTS

INTRODUCTION

by Steven Heller

Depictions of the future, as visualized on science fiction magazine covers, television, and films, triggered paroxysms of anticipation in many people like me. Computers were the cornerstone of this future, yet in the early years of the computer revolution the visual delight never quite matched the physical reality. After all, a computer is ostensibly a nondescript machine, and the advertisements for computers were equally conventional.

The sexiest computer advertisement I have ever seen was actually not an advertisement for a computer, but rather *about* a computer — well, kind of what we've come to know as a computer: the famous movie poster for Fritz Lang's 1927 dystopian science fiction masterpiece *Metropolis* that features an arresting graphic of the Maschinenmensch ("machine-person" or robot), a shiny, metallic automaton shaped like a woman.

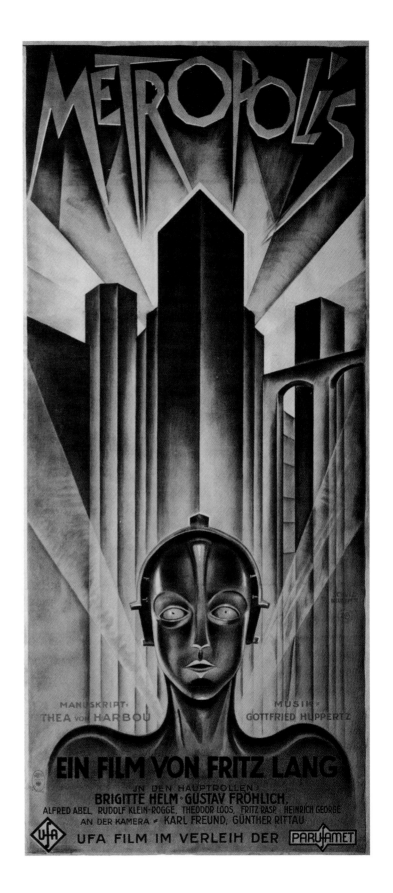

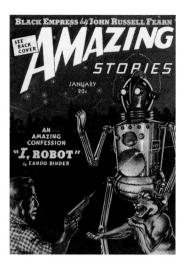

The Technocrats' Magazine, 1933 *(far left)*

Amazing Stories, 1933 *(left)*

Desk Set, 1957 *(opposite left)*

Augusta Ada King, ca. 1840 *(opposite right)*

The Maschinenmensch is the archetype for all the movie androids that followed—yet what is most important is that Maschinenmensch is by any other name a computer. Prior to the early 1960s and the first computer revolution, robots (from the Czech word robata for forced labor) were not touted as computers per se, but rather fictional, mechanical, humanoid devices. *Real* computers, in their earliest incarnations, were those behemoth mainframe "big brains" decked out with blinking lights, assorted dials, perpetually rotating reels of magnetic tape, and complex circuitry—all housed in correspondingly large temperature-controlled rooms and requiring several people to operate (not quite the Siri or Alexa of today). These machines were not like robots, which were the stuff of imagination—they were big, metal boxes with keyboards.

But they were the future even if the ad styles used to promote them were not nearly as inventive. Advertising creatives avoided using metaphor and allegory lest they romanticize, mythologize, and in the process of doing so, trivialize them. Businesses who the ads targeted saw their futures in terms of no-nonsense functionality.

If humanizing the computer served as a tool for actually selling computer products, it was not through the advertising campaigns. Instead, our visions of computers came through fiction. Motion pictures and TV shows featuring robots such as the Maschinenmensch; *Forbidden Planet*'s Robby the Robot (1956); *My Living Doll*'s AF 709 (1964–1965); *2001: A Space Odyssey*'s HAL 9000 (1968); *Star Wars*'

C-3PO (1977); and other artificial intelligence apparatuses fantastically (at times presciently) bridged the gap between people and machines.

In fact, computers were welcomed with both enthusiasm and trepidation, as personified in the 1957 Spencer Tracy-Katharine Hepburn romantic comedy *Desk Set*, in which employees of the fictional Federal Broadcasting Network research department were worried to death that the EMERAC mainframe (Electromagnetic Memory and Research Arithmetical Calculator) would replace them at their jobs. It was, in truth, a justifiable fear: When businesses eventually computerized they would indeed replace human beings. Whether or not imbuing computers with humanlike characteristics made them more acceptable is debatable, but giving these powerful machines names and personalities probably did make them a little less intimidating (or what is now called user-friendly).

Purchasing a computer was a huge investment, ergo selling them was a challenge for advertising agencies and promotion departments charged with the task. As the business machine field evolved from producing analog calculating machines to mainframes for voluminous data processing, the small handful of computer companies were more dependent on strong brand strategies and design to help earn their own recognition and success. The image of computers as time-savers, problem-solvers, and profit-generators were key assets in ad campaigns. As the machines developed with increased computing power, the graphics and jargon used to describe these virtues broadened. Yet, while computer ads and brochures

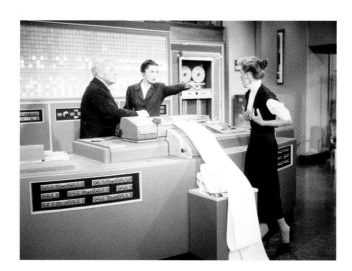
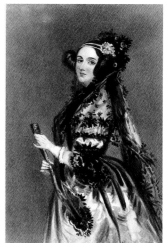

implied, "we've-seen-the-future-and-it-is-us," there was nevertheless some technophobia to overcome too—from taking our jobs away to something much worse: ruling our lives.

Pop culture contributed to our ambivalence towards computers (and continues to do so). One of the most disturbing, yet entertaining, *Twilight Zone* episodes centers around a computer: "The Old Man in the Cave" (1963) addressed the vexing problem of ceding humans' control to machines. The main plot revolves around an unseen yet ominous figure that governs the lives of a handful of survivors in a small, post-apocalyptic American town in 1974, 10 years after nuclear bombs had destroyed most of the earth. The eponymous old man in the cave determined a set of rules that the townspeople had to follow in order to survive. The messages came through a town elder, who interpreted the orders (for example, not to eat the contaminated canned food). When, owing to an existential crisis, the townsfolk discovered that the old man was actually a mainframe computer hiding in the cave, they rose up as a mob, destroyed it, and promptly died from consuming the radioactive food. As they perished, they realized how much they owed to this digital god—but resented it anyway and paid the ultimate price.

In addition to the wave of anxiety over machines, there was also a sense of amazement and anticipation for the future attached to computers that dated back to its early 19th century origins. Well over 100 years before the first computer revolution, the first machine to be described as a computer—which was known as

the Analytical Engine—was invented by a wealthy, English "gentleman scientist" by the name of Charles Babbage. An offspring of the Industrial Revolution and great-grandfather of steampunk (a style that combines contemporary high-technology with vintage Victorian veneers), the Analytical Engine would ultimately alter how data would be created, stored, and consumed. In theory, it predicted the modern computer, although in practice it had some mechanical kinks. Conceived in 1833, the engine incorporated an arithmetic logic unit, integrated memory, and was designed to tabulate logarithms and trigonometric functions. There's more: it was the precursor to a program-controlled, automatic, digital computing device able to perform any calculation and store the material as well. The story gets better: Babbage worked closely with Augusta Ada King, the Countess of Lovelace, wife of Lord Byron, and a genius mathematician who published the world's first algorithm. She is dubbed both a pioneer of computer programming and a preeminent philosopher regarding the relationship of society to technology.

Computers have been around for ages, although advertising for them is only 70 years old. What would ads for the Analytical Engine have appeared like? Visions of the future are always skewed towards what we already know and understand. The 20th century modern industrial and product designer Raymond Loewy used the term MAYA (Most Advanced Yet Acceptable) to explain how far forward an original concept can go before reaching the average person's capacity to comprehend or appreciate its newness.

The UNIVAC SYSTEM

Remington Rand, 1955
(opposite)

Grumman, 1954 *(right)*

IBM, ca. 1954 *(far right)*

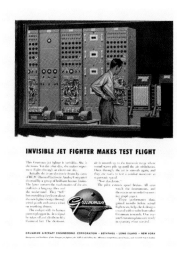

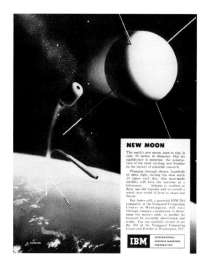

This is why most advertising rarely strays too far from the recognized norm.

The vast majority of examples featured in this book—from trade magazines and technology publications aimed at corporate customers and only later towards everyday consumers—span a curious range of approaches, especially compared to other advertising genres between the 1950s and 1990s. Unlike automobile ads, computer promos do not tend to emphasize the status and beauty of the machine itself. Unlike food or beverage ads, there is no focus on mouth-watering imagery or appetite appeal. Unlike pharmaceutical promos, there is not much allegory or metaphor used to depict the psychology behind the machinery.

Most early computer ads are conventionally straightforward. For instance, in a Univac brochure from 1956 (page 67), there is maybe a tip of the hat to quotidian appliance ads by showing a female model demonstrating the control panel. But then a sketchy rendering of a horse is presumably meant to illustrate the headline, "how to harness the profit-power of electronics." It's an awkward mix of a visual metaphor and real product. A later 1957 Univac advertisement for the "File-Computer for Business!" (page 48) is embarrassingly bland, being a photo of a monolithic mainframe surrounded by the backs of a few white men in gray suits. Where is the future here? Among the most curious of the conventional approaches is the Grumman ad (above left) headlined, "Invisible Jet Fighter Makes Test Flight." While the Grumman logo is full color (and not bad-looking either), the

representational pen-and-ink illustration for the massive computer is a gray halftone bathed in pink. Why pink? Perhaps because the "jet fighter" known as REAC (Reeves Electronic Analog Computer) is referred to in the copy as a "she." ("Actually, she is an electronic brain.") Makes you wonder.

Yet not all computer ads are decidedly banal. One Univac brochure from 1955 (opposite) shows an engagingly colorful, surreal planetary landscape with the atomic symbol in the center circling the earth. And a black-and-white IBM ad (above right) shows a startling artist's conception of a satellite hovering over the earth with the title "New Moon." Although its advertisements were handled by various agencies, IBM's graphic identity, overseen by design consultants Eliot Noyes and Paul Rand, always gave priority to design, allowing abstraction to be part of the visual vocabulary.

As computer systems expanded to include data storage banks, punch card readers, data input, and control stations, plenty of illustrated ads showed the increased amount of hardware being operated by men in suits (pages 51 and 70) or women controlling huge apparatuses (page 71). When the 1950s came to an end, the ads gradually became a little more abstract as well. This was a time when NASA's space program was in full swing, which would have been impossible without the aid of computers. So computers being utilized for space travel was the focal point of many ads. Advertising took full advantage of scientific discoveries to shift away from a focus on business to the space-age (page 87).

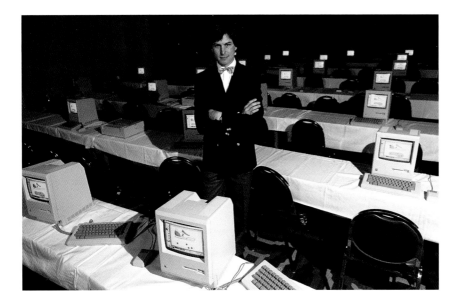

Steve Jobs, 1984 *(left)*

TEC, 1977 *(opposite)*

The biggest mold-breaking shift in computer promotion was an IBM brochure (page 92) showing a tight close-up of two fingers holding a tiny computer chip headlined, "On April 7, 1964 the entire concept of computers changed." It was no exaggeration either: This began the miniaturization of computers leading to the desktop machine represented by the Computer Terminal Corporation brochure for the Datapoint 3300 (page 93). Although it did not mark the end of ads and brochures displaying gigantic mainframe components, it began a veering away from formulaic advertising into a more artful space. Especially note-worthy are the Beckman Instrument ads (pages 98 and 99). Companies including Honeywell (page 88), Computer Terminal Corporation (page 94), Burroughs (page 106), and General Electric (page 111) used design and illustration to improve the sales narrative, while the Univac 1108-II brochure (page 105) adopted a more conceptual photographic approach.

When personal computers were introduced in the mid-1970s, the average person came much closer to having access to their own machines — and their destinies? Microsoft was founded, the first Apple computer was built, and the act of word processing entered our consciousness. Computer advertisements shifted away from primarily targeting businesses and government and opened its doors to the general public. However, only a few ad agencies were known to make exemplary ads. Mundane product photos and ham-handed typography didn't do the products

justice. Conceptually speaking, the TEC Model 70 (opposite) shown against a photo of a lightning storm had little charm and less allure. If you had assumed that when the 1980s rolled around, that new personal devices — including the first Macintosh in 1984 — and various incredible applications, such as video games, would make computer advertising more sophisticated out of necessity, you'd be wrong.

From a design perspective, ads like Megasoft (page 174) and Blue Sky (page 191) were garish and loud, echoing the primitive, pixelated interfaces that were state-of-the-art at the time. The future, at least technologically speaking, when seen through the lens of these advertisements, was not as exciting as one might have hoped. Conversely, TV advertising was decidedly more creative in the 1990s. Steve Jobs and Jonathan Ive began improving the product design for Apple in 1992, which influenced a new graphic design elegance. The quality of the ads during the 1990s at companies other than Apple and IBM continued to be a mixed bag of horsey and lovely.

Given this evidence, we might rightly conclude that promoting computers has not been overly clever as the machines virtually sell themselves. But it was all part of an evolutionary process. Apple would soon change the standard for advertising as well as the design of products, packaging, hardware, and stores. The evolution continues, and at the end of the day computers are so beautifully designed that selling them is not a problem.

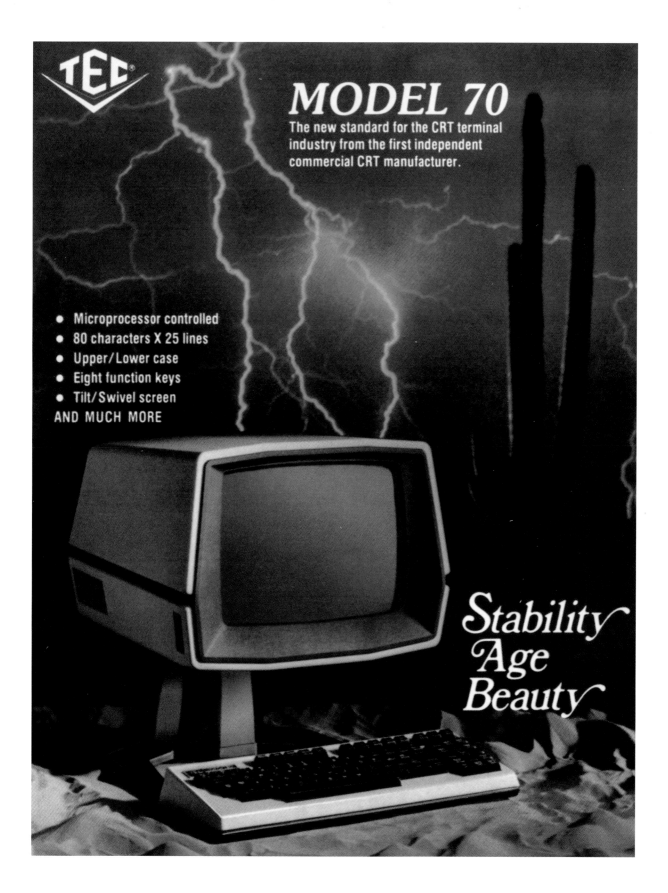

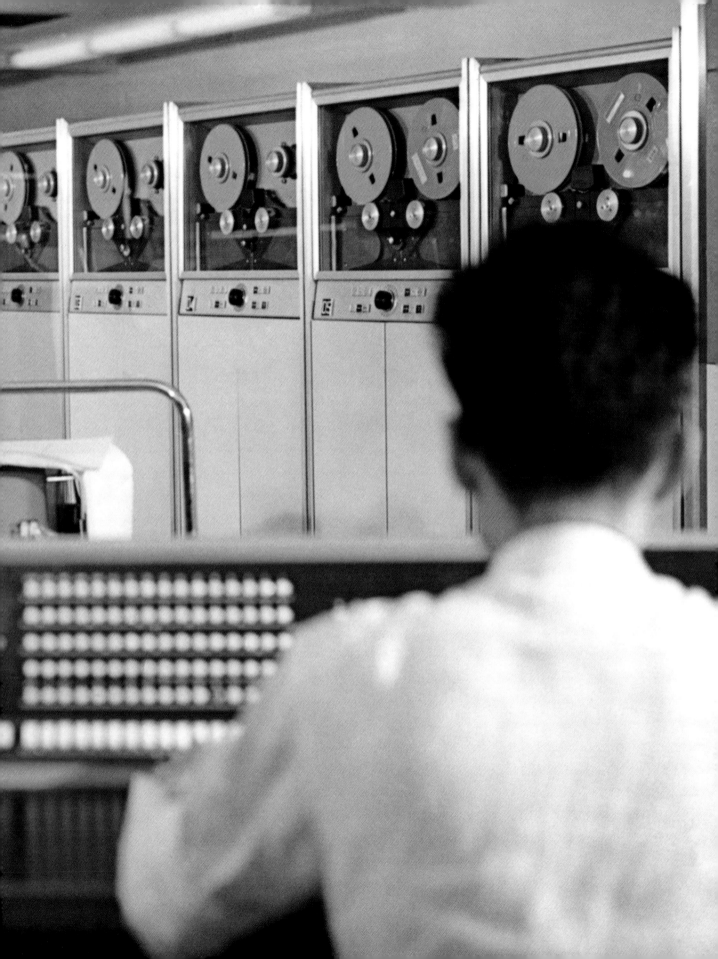

Hitachi, 1964 *(pages 16–17)*

IBM, 1934 *(opposite)*

SELLING TECH

by Ryan Mungia

At its root, the role of advertising is to generate a sense of longing and desire in the hearts and the minds of consumers. When done well, this ubiquitous marketing tool can transcend its utilitarian purpose — the selling of tangible goods and services — to become a cultural artifact, collectible, and mass-produced objet d'art.

Preceded by business machine advertisements in the 1930s, computer ads and sales brochures first started appearing in the late '40s, and followed many of the same graphic trends that characterized more standard consumer fare by brands such as Coca-Cola or Chevrolet, though some notable differences did occur. To understand the driving factors behind the selling of technology in the postwar era, one must consider the explosion that occurred — literally and figuratively — when the first atomic bomb blast went off in Alamogordo, New Mexico, on July 16, 1945. It was the moment when the impossible became possible, and a once far-reaching scientific concept became a cold, hard reality. A testament to man's ingenuity, intelligence, and ignorance all at once, it ushered in a new Atomic Era that would carry over into the decades to come.

RECORD
THE VOICE OF YOUR BUSINESS

The hum of your business has a meaning—men and machines have important information to impart . . . sales . . . number of pieces . . . time . . . depreciation . . . cost.

The International Electric Accounting Method interprets and records the voice of business — with accuracy and amazing speed.

The basis of this accounting method is the punched tabulating card. All business transactions, operating and statistical information are quickly registered in the cards in the form of punched holes. These cards automatically operate the sorting and tabulating machines into which they are later placed.

The flexibility of this modern method is enabling it to bring speed and economy to the accounting procedures of government and business in seventy-nine different countries. Let us show you how it can aid *you*. A complete demonstration awaits you at any of our branch offices.

International Business Machines include International Electric Accounting and Tabulating Machines, International Time Recorders and Electric Time Systems, International Industrial Scales, Dayton Moneyweight Scales and Store Equipment, Electromatic Typewriters and Radio Typewriter Systems.

ACCOUNTING SERVICE!

Any business, regardless of size, can now quickly obtain important figures and statistics through the International Tabulating Service Bureaus. These Bureaus are located in all principal cities and are equipped with the latest International Accounting and Tabulating Machines. They will work with you on any basis—weekly, daily or hourly. Write for folder No. 6-TS.

INTERNATIONAL BUSINESS MACHINES CORPORATION

GENERAL OFFICES: 270 BROADWAY, NEW YORK, N. Y. BRANCH OFFICES IN ALL PRINCIPAL CITIES OF THE WORLD

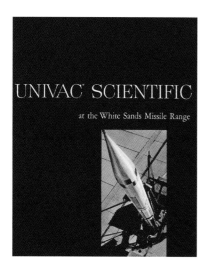

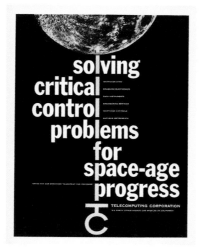

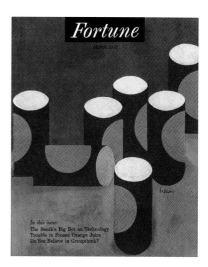

DEFENSE-MINDED

Technology companies were, in particular, at the forefront of this new cultural zeitgeist. As the Cold War expanded, and with it the ever-present specter of the Red Threat, America was in a race to be one step ahead of the Communists at all costs. Consequently, the United States government gave tech companies generous funds and resources to develop all manner of defense-minded devices.

Between 1952 and 1955, 80 percent of IBM's (International Business Machines) total revenue was generated by SAGE (Semi-Automatic Ground Environment), a program implemented by the U.S. government as an air defense system against Russian nuclear missile attacks. By 1958, more than 7,000 IBM staffers were working on the project, the final price tag of which is estimated to be around 8 billion dollars.[1] The scientific and financial results gained from this complex, decade-long endeavor assisted IBM in making huge strides ahead with its growing line of commercial mainframe computers.

Meanwhile, Honeywell, another giant American company, was engaged in making short-range nuclear missiles and unmanned aircraft for the U.S. Air Force. It was from these lucrative government contracts that the Midwest-based firm, which originally produced thermostats, was able to start selling computers for commercial business purposes by the mid-'50s. Defense iconography was implemented accordingly in each company's advertising material.

A focal point of defense iconography, missiles appeared repeatedly in computer advertisements throughout the 1950s. In a tastefully-restrained Burroughs ad from 1955 (page 39), a pair of missiles are shown alongside a sober headline which reads, "Electronic computers for guiding or intercepting." Then, in smaller copy down at the bottom, the ad references Burroughs' "accounting, statistical, and computing machines." Similarly, a Univac brochure from 1953 (above left) serves as a case study on how the 1103A Scientific System is utilized by the U.S. government at the White Sands Missile Range. On the last page, it says, ". . . just one of a complete line of Remington Rand Univac data processing systems available for business and scientific purposes." The subtext of these defense-minded ads and brochures seems to be that if the military relies on a Burroughs or Remington Rand machine for its missile program, imagine what the exact same computing power could do for one's business.

DEEP SPACE & THE ATOM

The cosmos—and the upcoming Space Race with the Soviet Union—was another common theme in computer advertising of the 1950s. A sales brochure for Remington Rand (pages 58–59) shows its Univac system hovering weightlessly among the stars with the headline: "First Choice of Modern Management." (Never mind the fact that this gargantuan piece of machinery might take up an entire floor of an office building.) With factory automation on the rise, a corollary expansion of business automation (the kind dealing with market analysis, inventory, and payroll) was needed to keep pace with a nation that was eager to spend money on goods for its new homes. Utilizing the iconography of space travel insinuated an alluring

Remington Rand, 1953
(opposite left)

Telecomputing Corporation,
1959 *(opposite middle)*

Fortune, 1952 *(opposite right)*

Remington Rand, 1955 *(right)*

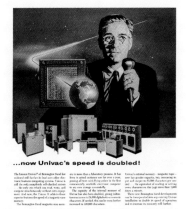

...now Univac's speed is doubled!

office of the future with less tedious work, increased creativity, and higher profit margins.

Often appearing in conjunction with outer space, the atomic symbol—which emerged as a ubiquitous motif not just in computer ads of the '50s, but a wide range of products and services from cars[2] to banking institutions—was visual shorthand for innovation. It also represented the stark possibilities of nuclear fallout, but advertising agencies took the initiative to put a more positive spin on the formidable symbol. For companies such as Burroughs and Bendix that were in the business of technology and discovery, plastering it on their sales and marketing material was practically a foregone conclusion.

If unabashed consumerism and abundance were reflected in the regular consumer product ads of the 1950s, computer ads took a slightly more conservative approach. The cost (and size) of mainframe computers dictated that only medium-to-large companies could afford them; as such, computer ads mainly appeared in trade magazines like *Fortune*. The copy for a 1957 Royal McBee LGP-30 computer (page 51) breathlessly exclaims, "No more lost time in executing preliminary calculations or modifying equations!" A Sperry Rand ad (page 57) promises that its Univac file computer will "open up a vast new world of profits." Typically at the bottom of an ad, a small paragraph would implore its reader to "write for a free brochure" to find out how a given computer could benefit one's business. Whereas magazine ads were a quick sales pitch, the marketing brochures, at times lavishly produced, were more of a deep dive into the nuances of a particular system. An IBM brochure from 1950 (page 36) has a section

entitled, "Electrons at Work," which is illustrated with detailed explanations of cathodes, negative electricity, and atoms—hardly everyman terminology of the day. Highly scientific, it spoke to engineers and scientists who must have been working at large manufacturing corporations. This kind of detail was the domain of marketing brochures more so than magazine ads.

STYLISTICALLY-SPEAKING

Computer advertisements from the 1950s were divided between two dominant styles: The first was the so-called shirt sleeve style of ad—a holdover from the 1930s and '40s—which tended to include several paragraphs of sales copy, sometimes in the form of a testimonial from a scientist, CEO, or business owner, alongside decorative headline text and various overlapping elements—the overall result of which was a busy design and a hard sell. The second was a decidedly more sophisticated European Modern style that was rapidly gaining traction in the postwar period with the art directors on Madison Avenue. Driven by technology itself, it was oftentimes characterized by sleek lines, organic shapes, minimal ornamentation, and striking juxtapositions. Form followed function with the intent of delivering messages in a more clear and direct way. Though these ads generally lacked humor and wit—qualities that would begin to appear more frequently with the Big Idea ads[3] of the following decade—the more modern computer advertisements and marketing brochures from the '50s, with their straightforward, no-nonsense approach, seemed inherently well-suited to the engineers, scientists, and business people who they were geared towards.

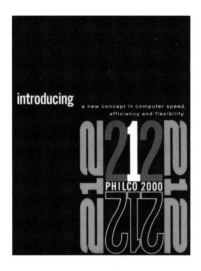

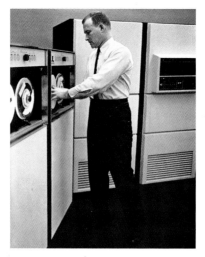

UN-ADVERTISED

Advertising has always been riddled with half-truths, reflecting the culture in a skewed way that belies its inner complexities — and computer ads from this era are no exception. From this vantage point, it was all men in gray flannel suits, industry, the military, and outer space as the connective tissue. However, there was an undercurrent at play that was not reflected in the ads or marketing material. The spirit of discovery and entrepreneurialism that would ultimately bring about the personal computer revolution was revealed as early as 1939 when David Packard and Bill Hewlett, both recent graduates from Stanford University in engineering, started making oscillators in Hewlett's garage in nearby Palo Alto. Though Hewlett-Packard would not enter the computer market until 1966, the template of self-invention was in place, and it had chosen Silicon Valley, roughly an hour south of San Francisco, as its mecca. The Eastern U.S. had its own version — Route 128 in New England, along which dozens of tech firms populated by graduates of MIT (Massachusetts Institute of Technology) and Harvard found their home in the 1950s — but due to a number of factors including a traditional East Coast business model based on vertical integration, proprietary knowledge, and dogged company loyalty, "the Magic Semicircle"[4] did not possess the same innovative synergy as its West Coast counterpart. Almost a complete antithesis to the more confined East Coast mentality was embodied by "the traitorous eight," a group of employees[5] at Shockley Semiconductor in Mountain View, California. In 1957, dissatisfied with the management style of their boss, William Shockley,

eight young scientists broke away to form their own company, Fairchild Semiconductor, which went on to become one of the most influential firms in the early, burgeoning days of Silicon Valley.

FIFTIES VERSION 2.0

At first glance, computer ads and sales brochures of the 1960s were not drastically different than those of the previous decade — the image of a person sitting at (or standing next to) a hulking piece of machinery; sophisticated arrangements of illustration and type; numbers or words strung out in an artful, almost mathematical way, occasionally veering towards abstraction — but there are several key differences. Indeed, by the end of the 1950s, the industry seems to have reached an unspoken agreement on how to sell tech. Computer ads and sales brochures did not exist in a vacuum and were undoubtedly influenced by larger cultural trends, but viewed as a whole a common language had emerged, just in time for the turbulent '60s when many standard conventions would be turned on their head.

As in the previous decade, IBM led the way, not only in terms of sales and popularity, but with top-notch ads courtesy of one of several advertising agencies it employed, including Marsteller, Rickard, Gebhardt & Reed for its data processing division. Such was IBM's influence that the mainstream media had begun referring to the industry as a whole as "IBM and the seven dwarfs," with Burroughs, CDC (Control Data Corporation), General Electric, Honeywell, NCR (National Cash Register), RCA (Radio Corporation of America), and Sperry Rand figuring as the diminutive

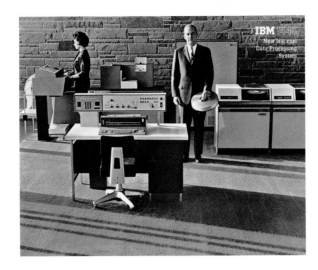

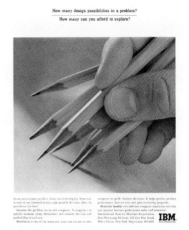

sidekicks. This moniker was a bit biased because although IBM was indeed responsible for dozens of technological innovations and arguably produced the most professional-looking ads and sales brochures, plenty of innovative work was being done outside of the IBM-sphere in the 1950s and 1960s, including non-commercial research facilities such as MIT, Stanford, and Cal Tech.

AESTHETIC SHIFT

Whereas illustration was the preferred choice for art directors in the 1950s, by the '60s photographic techniques started to appear with more and more frequency. Though this trend wasn't limited only to computers, the new favored medium coincided with an aesthetic shift in the computer itself whereby the appearance of the machine became a consideration. After all, what better way to showcase a computer's attractive qualities than with a photograph? A TEC brochure from 1964 (page 108) heralds its console's "outstanding appearance" and "modern, individualized styling tailored to your design." A Honeywell brochure from 1968 (opposite right and page 109) displays the H632's alluring black and gold façade in photographic detail. Sleek and modern, it looks more like furniture or a kitchen appliance rather than office equipment. It was an enticing selling point for businesses that wanted to add a little extra panache to their work environment to impress clients or visitors.

The biggest development within the realm of advertising in the 1960s was the emergence of the Big Idea, which grew out of the Creative Revolution.[6] One factor in this evolution was that ad agencies were attempting to connect to a suddenly massive youth culture—baby boomers, who were now becoming teenagers—by utilizing humor, irony, and wit. Rather than pummeling the consumer on top of the head with a hard sell, they used the more subtle art of insinuation. Graphics, or more often photographs, were displayed large on the page accompanied by a tagline or tightly edited sales copy. Of course, not all ads followed this dictum, and within the specialized niche of computer advertising there are even fewer examples, but a few companies such as IBM and Burroughs successfully integrated this concept with some memorable ads from this decade.

An elegant IBM ad from 1963 (above right) shows a close-up of a hand holding seven yellow pencils with the headline, "How many design possibilities is a problem? How many can you afford to explore?" The feeling of frustration is immediate—attempting to solve a complex math equation while using seven different pencils at the same time—but not if you have an IBM computer, the copy implies. Likewise, a striking Burroughs ad from 1964 (page 24) shows a dramatically-lit photo of its B200 system with the headline, "angry young computer." Beneath is a short bit of copy, which describes how the B200 can "outdo any computer in its class" and "gets angry" (just like a human!) when people purchase other machines "on the basis of name or initials." Without mentioning IBM by name, the ad pokes fun at the industry leader while simultaneously touting its own brand in a witty way.

Computer technology continued to be developed by the military industrial complex well into the 1960s and '70s, but due to unpopular foreign policy, including the

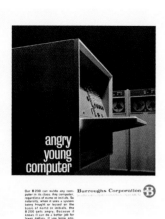

angry
young
computer

Our B 200 can outdo any computer in its class. Any computer, regardless of name or initials. So naturally, when it uses a system being bought or leased on the basis of name or initials, the B 200 gets angry. Because it knows it can do a better job for fewer dollars. If you know anybody who's considering a computer, do him a favor. Mention the Burroughs B 200. The same goes for anybody who's angry at his present computer. And we hear a lot of people are...

Burroughs Corporation ⒷCorporation

United States' entry into Vietnam in 1965, it became less common for tech companies to advertise their involvement with the government in developing weapons of mass destruction. In all actuality, the youth-driven counterculture movement of the '60s did not just influence the style of computer ads (the Big Idea) or the content (a decreased emphasis on military usage) but the development of computers themselves. As Stewart Brand wrote in a 1995 essay for *TIME* magazine, "Forget antiwar protests, Woodstock, even long hair. The real legacy of the '60s is the computer revolution."[7]

SEVENTIES RADICALISM
Indeed, the advent of the PC in the '70s was due, in part, to a series of developments by young techies who were rebelling against the notion that only those with money and privileged access (such as monolithic corporations) could use computers. They also believed that if technology and information were freely and readily available to everyone, it would bring about social change and positively impact the world. This philosophy, which Steven Levy outlines in his book *Hackers*, can be boiled down to several key concepts, including: "Access to computers should be unlimited and total; All information should be free; Mistrust authority—promote decentralization; You can create art and beauty on a computer; Computers can change your life for the better."[8]

The philosophical chasm—which had started to show at the seams in the 1950s and '60s—burst wide open in the '70s. On the one hand, you had the old guard—companies such as IBM and the seven

dwarfs—still producing cost-prohibitive mainframe computers that most people had never seen or knew much about outside of the occasional magazine ad or fictionalized movie version such as HAL 9000 in Stanley Kubrick's *2001: A Space Odyssey*. On the other hand, there was a rapidly growing contingent of young computer enthusiasts who formed groups and clubs for the purpose of sharing knowledge and resources. The People's Computer Company, founded in 1972 in Menlo Park, California, was one such club, whose premier newsletter stated, "Computers are mostly used against people instead of for people, used to control people instead of to free them. Time to change all that." The Homebrew Computer Club, which met for the first time in founder Gordon French's garage—also in Menlo Park—in 1975 was another magnet for local computer geeks, including Apple founders Steve Jobs and Steve Wozniak, who took inspiration from the club to develop the Apple I.

THE VALLEY
The fact that these clubs formed within a short distance of each other in the Silicon Valley was the result of a few factors, which John Markoff describes in his book, *What the Dormouse Said*. Although the East Coast had its own roots in computing, according to Markoff, "the Mid-peninsula, a relatively compact region located between San Jose and San Francisco, became a crucible not only for political protest and a thriving counterculture but also a new set of computing paradigms." He continues, "Personal computers that were designed for and belonged to single individuals would emerge initially in concert with a counterculture

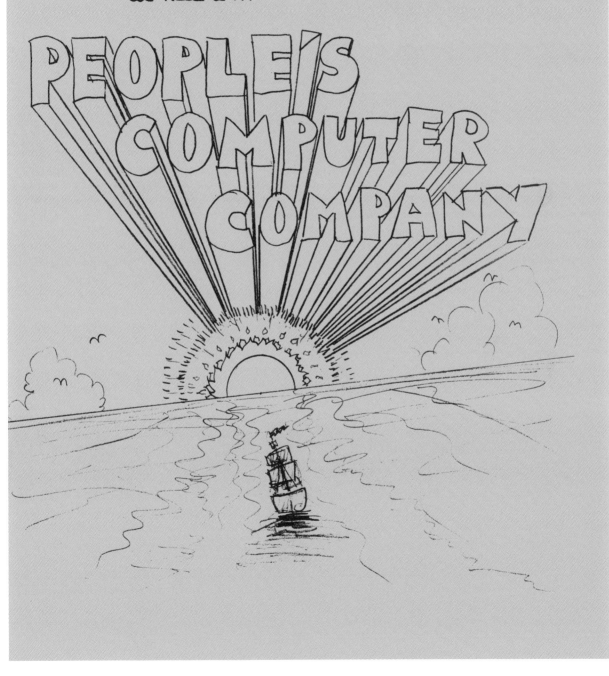

Byte, 1977 *(far left)*
Illustration by Robert Tinney

SCCS Interface, 1976 *(left)*

Atari, 1982 *(opposite left)*

Ted Dabney, Nolan Bushnell,
Fred Marincic, and Al Alcorn,
1973 *(opposite right)*

that rejected authority and believed the human spirit would triumph over corporate technology, not be subject to it."[9] So, in addition to nearby Stanford, which hosted two important research labs starting in the 1960s, the convergence of anti-establishment ideals that were specific to the Bay Area during that time—including the experimental use of LSD, which a number of the scientists from Stanford participated in—set the stage for those living there to think of the computer as an apparatus for social change. Through a series of technological advancements, this finally started coming to fruition in the 1970s.

HIGHS AND LOWS
While plenty of exciting growth was taking place on the technological front throughout the 1970s,[10] print advertising was suffering a bad hangover from the creative heights it had reached during the previous decade. One factor in the decline in the quality of print ads during this time was the continued rise of TV as the preferred medium for advertising dollars. In addition to a redistribution of funds towards TV commercials, national magazines such as *LIFE* and *LOOK* were folding beneath the weight of a declining readership and stagflation.

On the flipside, due to a fast-growing hobbyist computer culture, a number of technical magazines had materialized to fill the void. *Creative Computing* started appearing in 1974; *Byte*, "the small systems journal," began its run in 1975; Southern California Computer Society started publishing *SCCS Interface* in 1975; *Kilobaud*, an offshoot of *Byte*, materialized in 1977; and *Robotics Age* and *'68' Micro Journal* started

in 1979. While there were a lot of ads to be found in these magazines, they were, for the most part, geared towards all manner of hardware including sockets and memory boards. With a few exceptions, the bulk of these ads were produced in-house and were rather mundane from an aesthetics point of view. Top notch photography, illustration, and typography were not needed to sell a debugging system to a hacker who would have been much more interested in the item's technical specs than being seduced into opening up his or her pocketbook through clever wordplay and attractive visuals. Still, some of the larger and more ambitious companies such as IBM and Apple made serious attempts at producing quality print ads, and, as in previous decades, sales and marketing brochures continued their tradition of lavish production values and fantasy-promoting ideals.

COMPUTERS FOR THE PEOPLE
In 1977, three preassembled personal computers hit the marketplace, which came to be known as the "1977 Trinity," a phrase coined by *Byte*. This trio included the Apple II, Commodore PET (Personal Electronic Transactor), and Tandy TRS-80 Model I. Much like the arrival of the Ford Model T in 1908, widely regarded as the first affordable automobile, these systems, though not the first personal computers in existence, were the first that made computing accessible to non-hobbyist, middle-class consumers through their relative low-cost and ease of use. It was this new frontier of affordable and accessible PCs—along with a burgeoning home video game market—that would bring about a resurgence

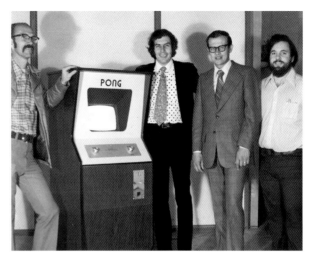

in computer advertising, this time geared towards the individual instead of the corporation.

The late 1970s and early '80s marks a gold-rush era for the personal computer and its sibling—also a descendant of the microchip—the home video game console, as companies such as Commodore and Atari made money hand-over-fist. Commodore, led by its founder Jack Tramiel, followed up the successful PET with the VIC-20 (Video Interface Chip) in 1981. Priced under $300, sold at regular retailers such as Kmart, and endorsed by Hollywood star William Shatner, it became the first computer to sell over one million units. Amazingly, despite the VIC-20's success, it would pale in comparison to Commodore's follow-up, the C64, released in 1982. Widely regarded as one of the most popular computers of all time, the C64 would sell between 10–17 million units.[11] At $600, it was less than half the cost of the Apple II ($1,395) and IBM PC ($1,355) making it an easy entry point for dozens of first-time computer-users.

INSERT COINS TO BEGIN

Though Atari did not invent the video game or the home video game console, the company, founded by Nolan Bushnell and Ted Dabney in 1972, was the first to demonstrate their widespread potential, in the process spawning an entire industry. After the success it experienced with the arcade version of *Pong*, Atari released the VCS (Video Computer System) in 1975. One year later, the company was sold to Warner Communications for $28 million. An improved home version, the 2600, was soon to follow and achieved massive success when it licensed *Space*

Invaders from Japan-based Taito, helping Atari gross $2 billion in 1980. This number continued to climb until 1983 when the bubble burst in what became known as "the video game crash of 1983."[12]

MASS APPEAL

The shift in *who* the computer was intended for—from business people and corporations in the Atomic Era to individuals beginning in the 1970s—marked a change in the tone of the ads and brochures. Whereas computer advertising in the 1950s and '60s tended to be straightforward and sophisticated, by the '80s, in an effort to appeal to a wide range of people, dumbed down humor became more common. A Leeco brochure from 1981 (page 28) features a morbid office tableau on its cover: In a beige, windowless room with paper strewn about in an apparent printer mishap, seven coworkers exhibit their frustration with software to the extent that one of them is on the verge of hanging himself, another has a gun pointed to his head, while the others sit at their desks in varying levels of distress. While this example is undoubtedly on the extreme end of the spectrum, it nevertheless points towards a general trend towards irreverence, perhaps in an effort to connect with a younger audience.

The fact that many regard 1984 as the birth of the personal computer reveals just how influential Apple's Macintosh campaign was. Steve Jobs wanted the Mac to be for the "person in the street," and its advertising campaign, both on TV and in print, was designed accordingly. The commercial, which aired during the Super Bowl (with a viewership of 78 million

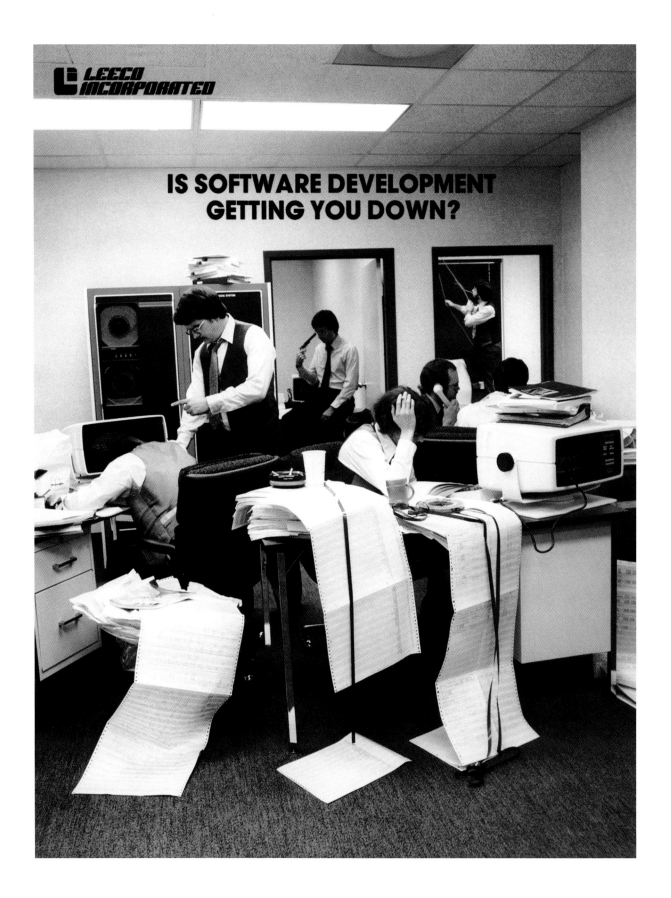

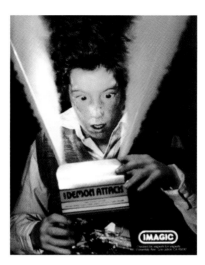

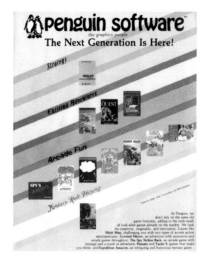

in 1984) was produced in collaboration with ad agency Chiat\Day and director Ridley Scott. Just as Burroughs did 20 years earlier with a series of ads pitting itself against IBM, the concept for Apple's Super Bowl commercial was an Orwellian dystopian reality in which people have been reduced to heads by an unnamed corporate entity. Although IBM isn't specifically mentioned, Big Blue's presence is cleverly insinuated by way of the commercial's blue-hued tones. Initially rejected by Apple's board members, the commercial aired regardless and was such a huge success that it became a water-cooler topic and news story in the weeks that followed. Then there was the print campaign, which tends to be overlooked in relation to the commercial, though it was also radical for the time. Apple purchased all 39 pages of ad space in the 1984 election issue of *Newsweek*. Simple yet elegant, the ads echoed the same thematic territory as covered in the TV commercial, which boils down to: the new Macintosh is for everyone, and personal computing — specifically Apple — equals democracy.

The scope of computer advertising expanded during the 1980s and '90s to include everything from security to software. In the previous decade, these types of ads were relegated to technical-oriented publications, but were now appearing in mainstream magazines such as *TIME* and *Newsweek*. Capitalizing on the success of *Star Wars*, a memorable 1986 ad for Maxell (page 188) depicts a corporate boardroom with C-3PO-esque robots sitting around a table with floppy discs in front of them. The headline states, "When computers get down to business, they move up to Maxell." Dystopian and AI-gone-wrong implications

aside, the ad works because of its sense of humor and straightforward message. By this time, there was no longer a need to explain the technology behind a given product in lengthy sales copy as the targeted audience shifted from business people and engineers to regular consumers. Brand recognition became much more important and this was achieved through a variety of means, off-color humor being but one example. This trend would continue into the following decade, as computer advertising became less about the physical piece of machinery and more about conveying a mood.

CYBERNETIC MEADOW

Echoing a poem by Richard Brautigan entitled, "All Watched Over by Machines of Loving Grace,"[13] the iconography of natural landscapes ironically became a reoccurring motif in computer advertising towards the end of the millennium, affording an organic touch to an increasingly digital world. First published in 1967, the poem by Brautigan describes "a cybernetic meadow/where mammals and computers/live together in mutually/programming harmony . . . " Whether interpreted as a naïve prediction of utopia or a biting social critique, it set forth a vision of computers and nature that became a harbinger of technology ads at the end of the century.

To wit, an Adobe ad from 1998 (page 210) shows a full-page photo of a sprawling, manicured lawn with a large UFO-shaped topiary planted in the middle. A man sits beneath it in the shade — a wide grin on his face — with the headline, "Wouldn't it be nice if your work was impossible to ignore?" A short paragraph below describes how Adobe software can help you

Lord, 1986 *(left)*

The Computer Time Bomb, 1998 *(opposite)*

stand out in business. Reminiscent of a Big Idea ad in which the reader is rewarded for putting two and two together, the ad makes a case for Adobe without showing the technology but presenting us with an emotion instead. The iconography of nature would continue to appear in various incarnations throughout the decade.

VIRTUAL CONVERSION

As the '90s came to a close, mainstream magazines were saturated with computer advertisements. No longer characterized solely by the giant mainframe, the definition of selling tech spun off into a profusion of categories and subcategories of technological peripherals — websites, software, cellular phones, pagers, fax machines, video games, robots and, of course, the computer. Paradoxically, in conjunction with the rise of these various devices (not to mention the Internet), the slump first experienced by print in the 1970s would begin to accelerate as advertising dollars shifted towards digital media. There were exceptions — *Wired*, for example, began its successful run in 1993 as the first magazine to cover the culture of technology — but, on the whole, the computer, which initially relied on print to bring it to market, was now on the inevitable trajectory towards making that medium obsolete. According to Perry Chen, who examined the Y2K phenomenon in a 2014 exhibition called *Computers in Crisis*, just as "the printing press was, rightfully, feared as an existential threat to oral storytelling traditions," digital technology "filled this narrative as a consequence of our increasing reliance on computers."[14] As such, the '90s marks the end of an era with the ads and sales brochures representing not a complete history of the computer in the second half of the 20th century, but a snapshot of a time when technology was catapulted into public awareness by way of an older, archaic medium.

A prelude to our increasingly digital world, the Y2K crisis emerged in the final years of the 1990s as a mainstream media frenzy reminiscent of Atomic Era nuclear panic. Magazine editorials, books, and stores — Y2K prep centers where one could purchase survival supplies for the impending doom — began to appear with more and more frequency as the year 2000 approached. The seismic shift that occurred in our collective consciousness during this time period is significant. What we initially understood computers to be — benign devices on which to do your homework, play video games, or keep track of payroll — suddenly morphed into something much more nebulous and nefarious. While many were wondering whether this computer glitch would spell the end of civilization, Danny Hillis, in a 1999 article for *Newsweek*, argued that it already had: "We are no longer in complete command of our creations. We are back in the jungle, only this time it is a jungle of our own creation. The technological environment we live within is something to be manipulated and influenced, but never again something to control. There are no real experts, only people who understand their own little pieces of the puzzle. The big picture is a mystery to us, and the big picture is that nobody knows."[15]

MANAGEMENT BRIEFING

How to
Keep the
Century
Date Change
From
Killing
Your Organization

The Computer Time Bomb

Minda Zetlin

1950–1959
AEROSPACE & ACCOUNTING

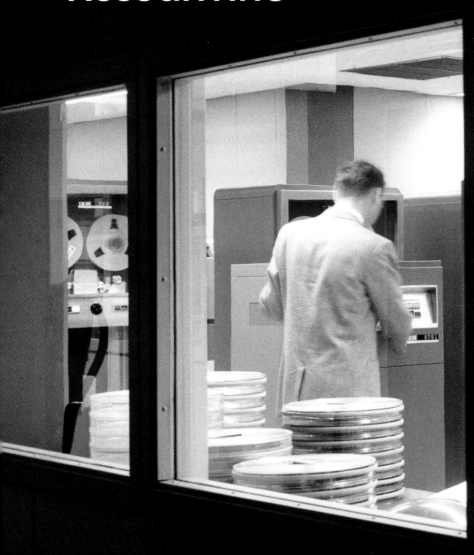

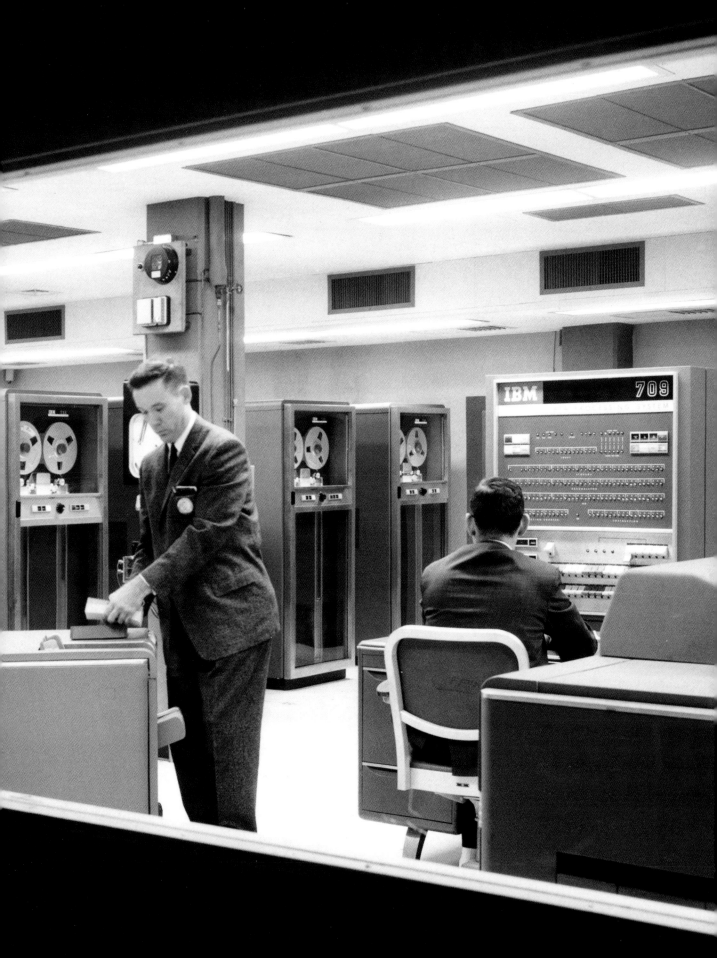

1950
Edmund Berkeley's blueprint for an "electric brain" is published in *Radio Electronics* magazine.

1950
The Atlas computer is designed by ERA (Engineering Research Associates) for the U.S. Navy.

1950
Isaac Asimov writes about the relationship between humans and computers in *I, Robot*.

1951
Alan Turing creates a series of questions to determine the intelligence of computers.

1951
One of the first robots is created by Edmund Berkeley; he calls it Squee, the mechanized squirrel.

1952
IBM releases its new magnetic tape storage system, soon to be an industry standard.

1952
Grace Hopper demonstrates that instructions can be delivered to a computer by way of words.

1952
A Univac computer predicts that Dwight D. Eisenhower will win the U.S. presidential election.

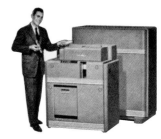

1952
IBM begins to sell its scientific computers commercially with the 701, aka the "Defense Calculator."

1953
The Navy-funded Whirlwind computer at MIT is the first to use magnetic core memory.

1953
IBM announces a new, more reliable computer for "ordinary business" purposes—the 650.

1955
Stanford Research Institute creates an automated banking system for Bank of America.

1955
IBM-users in Los Angeles meet regularly to discuss computers, calling their group SHARE.

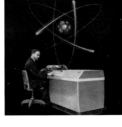

1956
Royal Precision's LGP-30 is one of the first computers designed specifically for individual use.

1956
IBM's new 305 RAMAC computer with "super memory" becomes a new model for hard disc storage.

1956
Sci-fi movie *Forbidden Planet* features an android character named Robby the Robot.

1957
IBM releases a new programming language that makes burdensome code more accessible.

1957
Fairchild Semiconductor, an early developer of silicon chip technology, is founded.

1957
The first digital scan is produced by Russell Kirsch at the National Bureau of Standards.

1958
Jack Kilby invents the integrated circuit at Texas Instruments and paves the way for microchips.

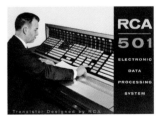

1958
RCA releases a modular, color-coded computer based solely on transistors—the 501.

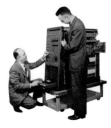

1959
MIT, home to a lively hacker culture, offers a new course in computer programming.

1959
Throughout the decade, IBM develops a comprehensive air defense system called SAGE.

1959
Many people's knowledge of computers is limited to print advertising and science fiction.

electrons at work

IBM, ca. 1958 *(pages 32–33)*

IBM, 1950 *(opposite)*

Nuclear Development Associates, 1953 *(right)*

Hogan Laboratories, Inc.
155 Perry Street
New York, N. Y.

Circle Computer Division
Nuclear Development Assoc., Inc.
80 Grand Street
White Plains, New York

the easy to use

Bendix G·15

GENERAL PURPOSE DIGITAL COMPUTER

Bendix ® ✕ *Computer* *division of* BENDIX AVIATION CORPORATION

Bendix, 1955 *(left)*

Burroughs, 1955 *(opposite)*

Electronic computers

for guiding or intercepting

INSTRUMENTATION
Aircraft and Navigation

CONTROL SYSTEMS
Airborne and Shipborne

COMMUNICATIONS
Equipment

COMPONENTS
Electronic and Magnetic

ELECTRONIC COMPUTERS
Commercial and Military

Burroughs is actively engaged in defense projects in all these fields. Burroughs, through its extensive facilities, is equipped to perform the complete cycle of work—from analytic and study phases, and the development of original concepts and design ideas, through large volume production and testing. Address inquiries to Burroughs Corporation, Detroit 32, Michigan.

Burroughs

Known world-wide for outstanding, high-speed accounting, statistical and computing machines, Burroughs also occupies a strategic position in the advanced field of electronic computers and data processing equipment.

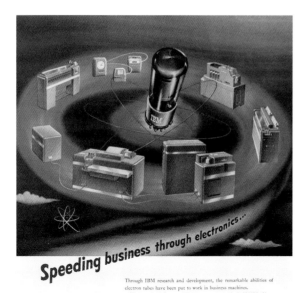

Speeding business through electronics...

Through IBM research and development, the remarkable abilities of electron tubes have been put to work in business machines.

Electron tubes—fast, versatile, accurate—are used in the IBM Machines pictured here to calculate at extraordinary speeds, to "remember" the answers to intricate computations, to follow long series of instructions, to control the flow of electricity with amazing precision.

IBM Electronic Business Machines are cutting the time between questions and answers—helping science and industry produce more good things for more people.

The IBM machines illustrated use electronic principles. Clockwise from the top, they are: Electric Time System, with Electronic Self-regulation; Alphabetical Collator; Statistical Machine; Card-programmed Calculator, including Calculating Punch; Punched Card Sorter. For descriptive literature, write to Dept. S.

 INTERNATIONAL BUSINESS MACHINES CORPORATION
590 MADISON AVENUE · NEW YORK 22, NEW YORK

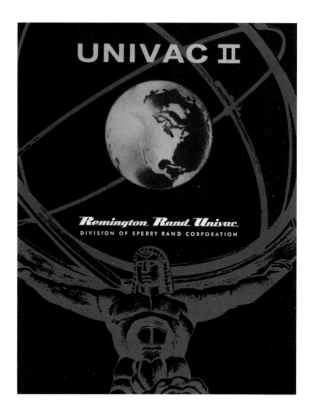

IBM, 1950 *(above left)*

Sperry Rand, 1957 *(above right)*

Underwood, 1956 *(opposite)*

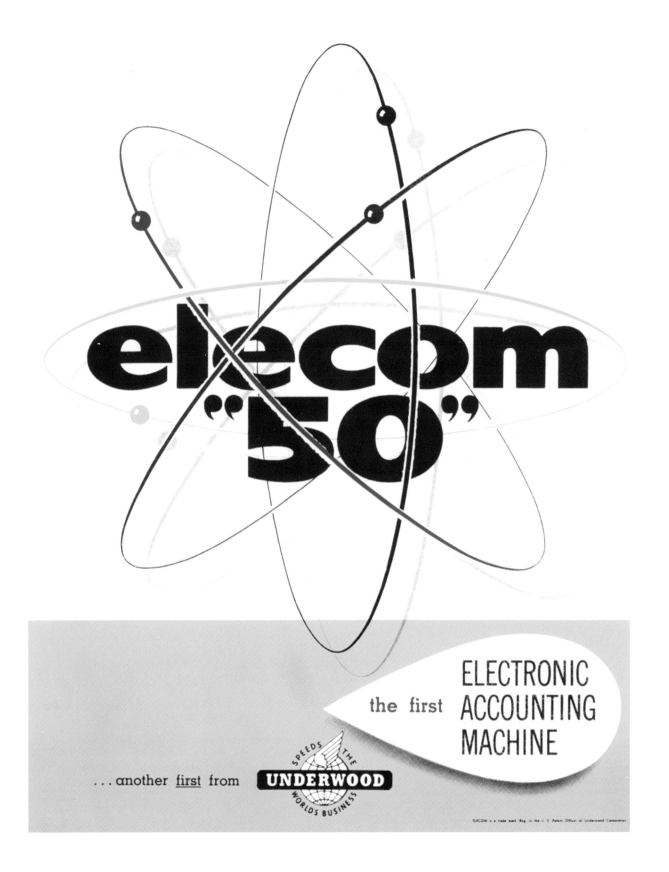

Bendix, 1955 *(left)*

Nuclear Development Associates,
1953 *(opposite)*

CIRCLE
COMPUTER

A GENERAL PURPOSE DIGITAL COMPUTER FOR SCIENCE & ENGINEERING

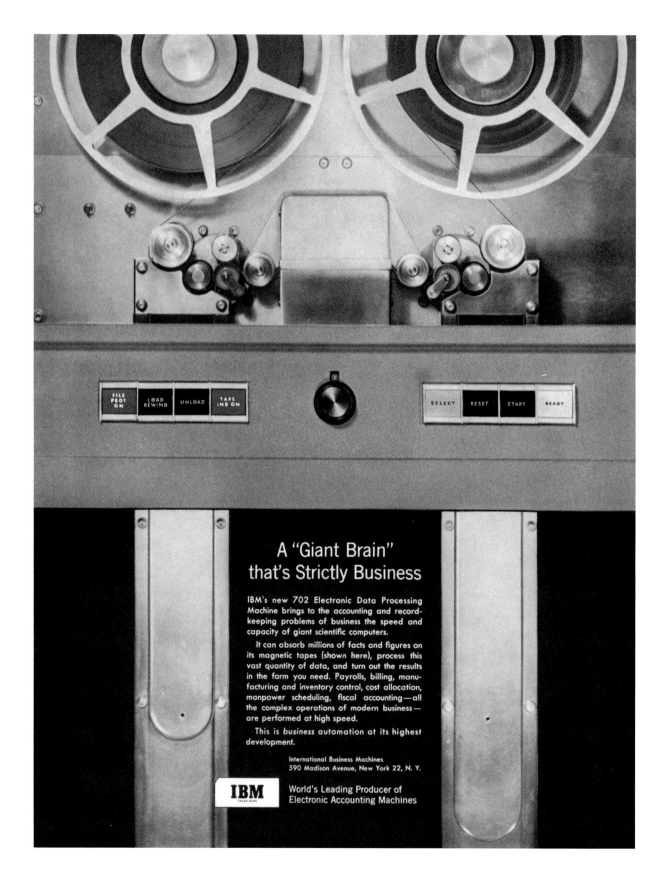

A "Giant Brain" that's Strictly Business

IBM's new 702 Electronic Data Processing Machine brings to the accounting and record-keeping problems of business the speed and capacity of giant scientific computers.

It can absorb millions of facts and figures on its magnetic tapes (shown here), process this vast quantity of data, and turn out the results in the form you need. Payrolls, billing, manufacturing and inventory control, cost allocation, manpower scheduling, fiscal accounting—all the complex operations of modern business—are performed at high speed.

This is *business* automation at its highest development.

International Business Machines
590 Madison Avenue, New York 22, N. Y.

IBM World's Leading Producer of Electronic Accounting Machines

IBM, 1954 *(opposite)*

Remington Rand, 1955 *(right)*

The Univac Scientific Computing System

Launching Tomorrow's Satellite

When the first man-made satellite is launched on its orbit around the earth, it will owe its existence to the thousands of missiles which have preceded it, and to the careful analysis of their patterns of flight. The Univac Scientific of Remington Rand has speeded this effort immeasurably, handling flight analyses for the nation's guided missile program.

Each missile firing, each analysis, involves enormous amounts of in-flight data, with manual computations normally requiring from 250 to 500 hours. This staggering work load is accomplished by the Univac Scientific Electronic Computer in approximately *4 to 8 minutes.*

Because of its ability to reduce large volumes of data at tremendous speeds, the Univac Scientific System easily handles even the most difficult research problems. Its speed is matched by many other outstanding characteristics, including: superb operating efficiency, obtained through large storage capacity . . . great programming versatility . . . the ability to operate simultaneously with a wide variety of input-output devices . . . and far greater reliability than any computer of its type.

For more information about the Univac Scientific System or for information about how you might apply the system to your particular problems, write on your business letterhead to . . .

ELECTRONIC COMPUTER DEPARTMENT **Remington Rand** ROOM 2116, 315 FOURTH AVE., NEW YORK 10
DIVISION OF SPERRY RAND CORPORATION

a GIANT STEP in automation for business

Announcing the Remington Rand UNIVAC FILE-COMPUTER . . . a medium-size data-processing system

The speed of electrons . . . the memory of magnetism . . . and over fifty years' experience in business records and control . . . all these have been built into the Univac File-Computer.

Here's building-block flexibility that adapts to practically *any* situation — an electronic brain with common-language input-output for application after application. Here's machine versatility that can file, find, compute and summarize *simul-taneously*—a medium-size system that can, for example, handle billing, inventory and sales analysis as a single operation.

Here's the truly automatic office *your* top management should know about. For this newest Univac can bring you lower costs, increased production, better customer service and freedom from supervisory routines. Remington Rand will gladly call to show you *how* and *where*.

ROOM 1802, 315 FOURTH AVENUE, NEW YORK 10

Remington Rand
DIVISION OF SPERRY RAND CORPORATION

PUNCHED-CARD ELECTRONICS

Sperry Rand, 1955 *(opposite)*

IBM, 1956 *(right)*

At the height of the Cold War, IBM was developing SAGE, an air defense system initiated by the U.S. government to protect the nation against a potential attack by the Soviet Union. At the time, it was the most ambitious computer program ever attempted, and, as such, IBM needed a massive staff to bring the project to fruition. To this end, ads in magazines invited engineers to pursue a career in the "wide open field in the electronics industry."

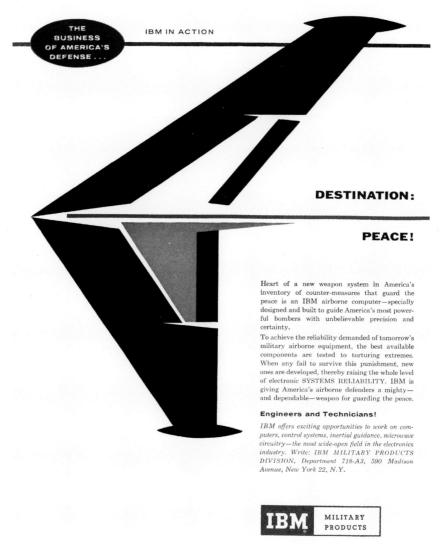

THE BUSINESS OF AMERICA'S DEFENSE . . .

IBM IN ACTION

DESTINATION:

PEACE!

Heart of a new weapon system in America's inventory of counter-measures that guard the peace is an IBM airborne computer—specially designed and built to guide America's most powerful bombers with unbelievable precision and certainty.

To achieve the reliability demanded of tomorrow's military airborne equipment, the best available components are tested to torturing extremes. When any fail to survive this punishment, new ones are developed, thereby raising the whole level of electronic SYSTEMS RELIABILITY. IBM is giving America's airborne defenders a mighty—and dependable—weapon for guarding the peace.

Engineers and Technicians!

IBM offers exciting opportunities to work on computers, control systems, inertial guidance, microwave circuitry—the most wide-open field in the electronics industry. Write: IBM MILITARY PRODUCTS DIVISION, Department 718-A3, 590 Madison Avenue, New York 22, N.Y.

IBM MILITARY PRODUCTS

MILITARY PRODUCTS * DATA PROCESSING * ELECTRIC TYPEWRITERS * TIME EQUIPMENT

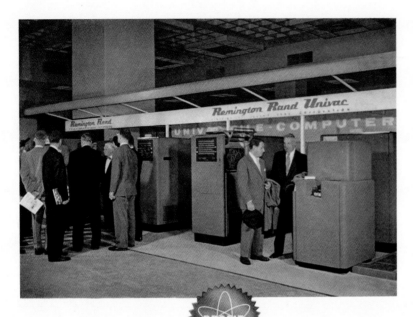
Sperry Rand, 1957 *(left)*

IBM, ca. 1958 *(opposite)*

The influence of the IBM 305 RAMAC (Random Access Method of Accounting and Control) cannot be overstated. Known as a machine with "super memory," it became the model by which other hard discs would be modeled from that point forward. It allowed for fast, random access to information, taking mere seconds, whereas before it could take hours or sometimes days. It's the same concept by which many devices still operate today.

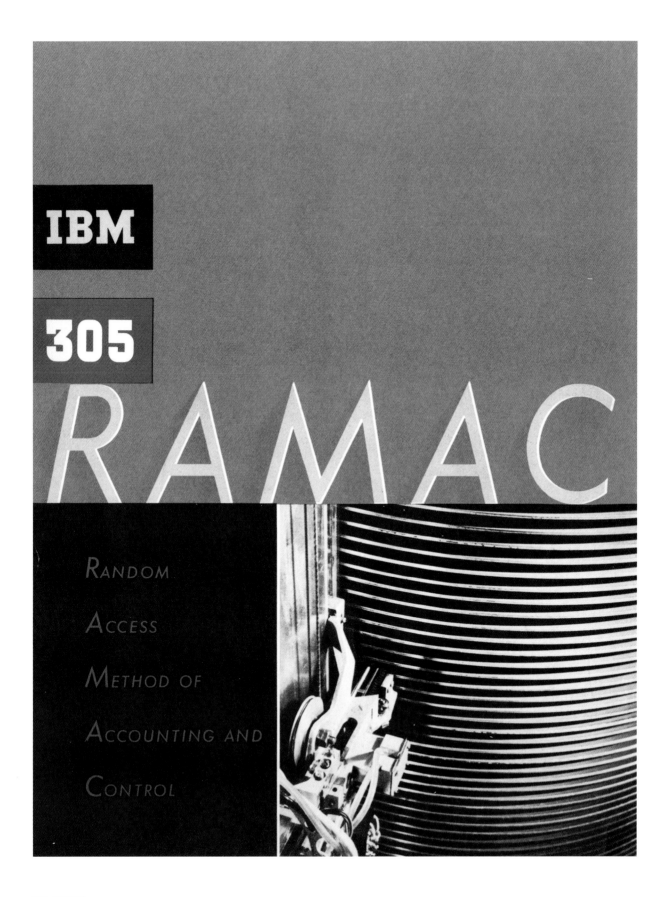

IBM

305

RAMAC

Random

Access

Method of

Accounting and

Control

PIERCING THE UNKNOWN

This IBM electronic tube assembly cuts through the unknown like a rocket through the stratosphere.

It probes the mysteries of the atom's core; predicts critical wing flutter of fast aircraft; traces paths of light through a lens system; calculates trajectories of guided missiles; plots the course of planets for the navigator.

It calculates payrolls, inventories, costs; points out savings of time and money.

These compact, pluggable units are the heart of IBM Electronic Calculators.

INTERNATIONAL BUSINESS MACHINES

IBM

IBM Electronic Business Machines are vital defense weapons in the hands of our nation's industrial engineers and scientists.

IBM, 1951 *(opposite)*

Royal Precision, 1957 *(right)*

At last! A large-capacity electronic computer you use right at your desk! ROYAL PRECISION LGP-30

High-speed computation at the lowest cost ever for a complete computer system

No more waiting in line for those answers you need! No more lost time in executing preliminary calculations or modifying equations! Not with the LGP-30! Wheeled right to your desk, operated from a regular wall outlet, LGP-30 allows you to follow your work personally from beginning to end . . . to change formulae on the spot . . . to simulate optimum designs without weeks of mathematical analysis. Thus you get faster answers . . . added time for *creative* work.

Easy to use. LGP-30 is a general-purpose stored-program computer — internally binary, serial, single address. Just the few orders in the command structure give complete internal programming. Controls are so simplified, you get an "overnight" feel for your computer.

Unusual memory capacity. With a magnetic drum memory of 4096 words, LGP-30 is the most powerful computer of its size yet developed. Fully automatic, it executes self-modifying programs.

Exceptional versatility and value. Both the scope of LGP-30's applications and the range of calculations it

can perform are almost limitless. It gives speed and memory equal to computers many times its size and cost, yet initial investment is the smallest ever for a complete computer. Maintenance costs are extremely low . . . service facilities available coast-to-coast.

Outstanding features of LGP-30

• Alpha-numeric input-output via electric typewriter or punched paper tape. • Optional input-output equipment available. • Unusually large memory — 4096 words. • Library of sub-routines . . . programs for wide variety of applications. • Mobile . . . no expensive installation . . . self-cooled. • Nation-wide sales and service.

For further information and specifications, write Royal McBee Corporation, Data Processing Equipment Division, Port Chester, N. Y.

ROYAL McBEE
WORLD'S LARGEST MANUFACTURER OF TYPEWRITERS AND MAKER OF DATA PROCESSING EQUIPMENT

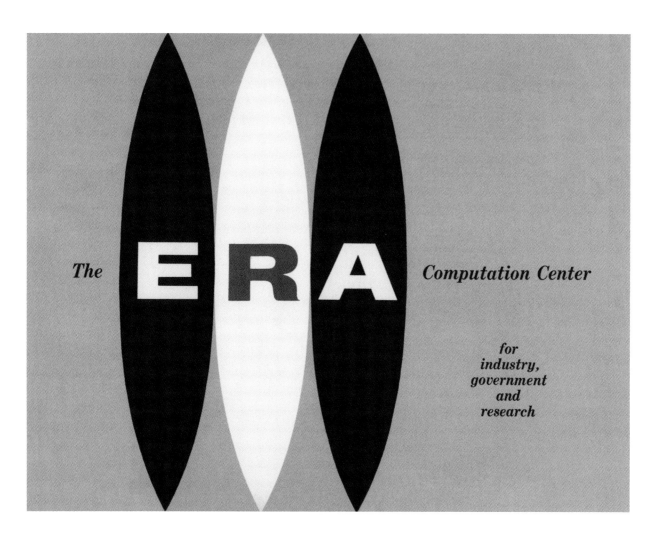

ERA, 1950 *(above)*

Bendix, 1956 *(opposite)*

An Introduction to the

FERRANTI

MERCURY COMPUTER

Ferranti, 1956 *(opposite)*

Bendix, 1955 *(right)*

POWERFUL, LOW COST
...EASY TO USE

Bendix G·15

GENERAL PURPOSE
DIGITAL COMPUTER

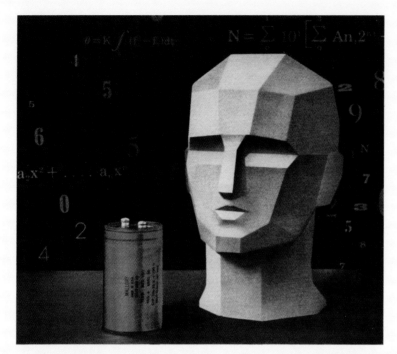

To Help a Computer Concentrate

...By filtering distracting voltage pulses, Mallory capacitors keep a computer's memory from wandering.

To help keep electronic brains safe from error and breakdown, Mallory has developed a series of computer capacitors that set entirely new standards for efficient filtering and long service. Used by the hundreds in the power supply, they assure a smooth-as-silk flow of current to the computer's thousands of tiny parts.

The manufacturing methods Mallory had developed for building extra life and performance into capacitors gave us a head start in tackling this new application. Mallory computer capacitors are produced by special techniques under conditions as carefully controlled as those in a hospital operating room to

assure they last as long as the computer itself and help eliminate costly trouble-shooting and down time.

These new capacitors are the latest development of Mallory pioneering in the design and production of precision electronic components. Today you find Mallory products in miniature hearing aids, your TV set and car radio, and space satellites. And they will be working in tomorrow's electronic marvels.

Electronic, Electrical and Special Metal Components • Dry Battery Systems • Semiconductors • Timer Switches

Mallory, 1959 *(left)*

Sperry Rand, ca. 1956 *(opposite)*

In American postwar society of the 1950s, there existed both a fear and an optimism of the atom's potential. On the one hand, it represented anxiety over a potential nuclear attack. On the other hand, it was a symbol for technological discovery. Harnessing the latter, companies such as Sperry Rand employed the atomic symbol as visual shorthand for cutting-edge innovation.

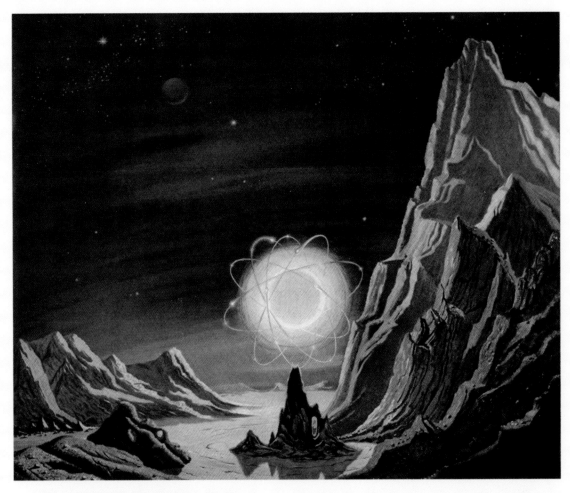

ELECTRONICS... *opens up a vast new world of profits*

How much would *your* profits increase if you could get fast, accurate and inexpensive answers to questions like: *Where are new markets shaping up? Which sales policy will pay off best? Are our costs out of line? Why? Should we make it or buy it? Where can we streamline operations?*

UNIVAC FILE-COMPUTER pulls full answers to such questions from your ordinary business records and operating data! Serves them up while they're piping hot – while they mean money in opportunities seized, costs reduced, customers pleased, contracts won. Magic?... no, electronics!

All this *in addition* to automation of your routine bookkeeping: billing, inventory, payroll, etc. For Univac File-Computer breaks through the barrier of human limitations, provides electronic speed and accuracy for office procedures. It's a giant step toward the completely automatic office.

Find out what this medium-size Univac can do for your firm. Write for free booklet: TM939, Room 1206, 315 Fourth Ave., New York 10.

UNIVAC® FILE-COMPUTER

Remington Rand Univac
DIVISION OF SPERRY RAND CORPORATION

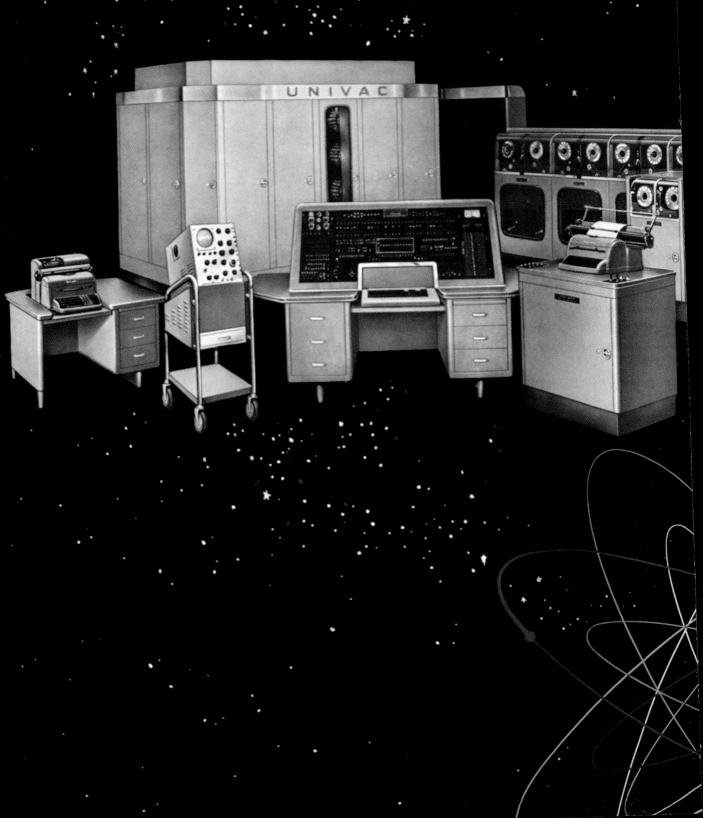

The Remington UNIVAC

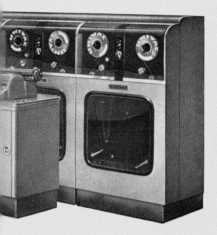

FIRST CHOICE OF MODERN MANAGEMENT

First so-called "giant brain" on the market—first in large-scale production — first electronic computing system to satisfy the diverse needs of business management — Univac is the acknowledged leader in the electronic computing field.

Everyone has heard about the scientific computing marvels that this type of equipment is capable of performing. But less well known are the many equally important commercial routines which the Remington Rand Univac — and Univac alone — handles automatically and economically, with matchless accuracy, to achieve results such as these:

- Classifying survey results with time savings of 30 to 1 and dollar savings of 5 to 1.

- Performing, in 2 days, public utility rate studies which formerly required 21 man-weeks.

- Compiling, in 16 hours, actuarial statistics which would require 2 *machine-months* with punched-card equipment.

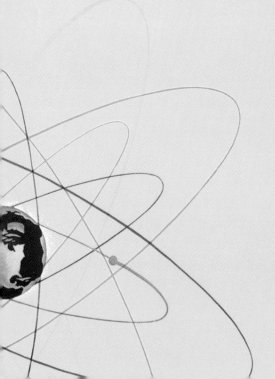

introducing a new language for automatic programming

UNIVAC® FLOW-MATIC

by *Remington Rand Univac*
DIVISION OF SPERRY RAND CORPORATION

Remington Rand, 1955
(pages 58–59)

Sperry Rand, 1957 *(opposite)*

IBM, 1952 *(right)*

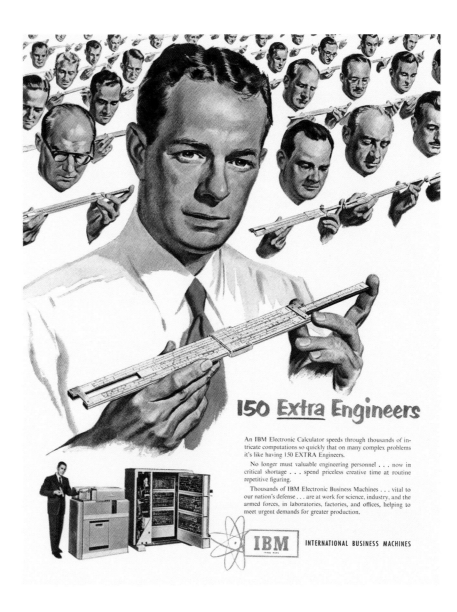

150 Extra Engineers

An IBM Electronic Calculator speeds through thousands of in-
tricate computations so quickly that on many complex problems
it's like having 150 EXTRA Engineers.

No longer must valuable engineering personnel . . . now in
critical shortage . . . spend priceless creative time at routine
repetitive figuring.

Thousands of IBM Electronic Business Machines . . . vital to
our nation's defense . . . are at work for science, industry, and the
armed forces, in laboratories, factories, and offices, helping to
meet urgent demands for greater production.

IBM INTERNATIONAL BUSINESS MACHINES

IBM, 1959 *(left)*

Sperry Rand, 1957 *(opposite)*

P
PR
PRO SYSTEMS
PROG YSTEMS
PROGR STEMS
PROGRA TEMS
PROGRAM EMS
PROGRAMM MS
PROGRAMMI S
PROGRAMMIN
PROGRAMMING

the Univac® Data Communications System

ANOTHER SERVICE OF . . .

MANAGEMENT SERVICES AND OPERATIONS RESEARCH DEPARTMENT

Remington Rand Univac
DIVISION OF SPERRY RAND CORPORATION

...a major breakthrough for Business-America

Sperry Rand, 1958 *(opposite)*

Honeywell, ca. 1959 *(right)*

Much of Honeywell's output in the
'50s centered around contracts from
the U.S. government to engineer
and manufacture defense systems
against the Red Threat. In 1953, it
developed an automated control
unit for airplanes; it also worked
with the Air Force to develop a
short-range nuclear missile called
the Wagtail. Honeywell started
making its own computers in 1955
as the Datamatic Corporation to
compete with IBM's mainframes,
fueled by profits from its lucrative
defense contracts.

CONTROL
first step to
space

HONEYWELL INERTIAL PLATFORM

Space flight requires incredibly accurate control. And
of all the guidance and navigation systems known to-
day, inertial systems are the most advanced. Different
from radio or radar controlled systems, the inertial
system is self-contained, allowing the missile to be on
its own from moment of launching. A pioneer in the
field, Honeywell today is an acknowledged leader in
the design and aseptically-clean manufacture of in-
ertial systems and components. Shown is a Honey-
well inertial platform that includes the most accurate
gyros in the world. It is one of 12,000 control devices
made by Honeywell. If you have a problem in the realm
of control, Honeywell's 74 years of experience can help
you. Call or write Honeywell, Minneapolis 8, Minn.

Honeywell
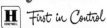 *First in Control*

U.S. Steel & Univac*

United States Steel Corporation is another of the great American industries that have had the vision to realize the full benefits of Univac data-processing. For Univac, today, is providing U. S. Steel with the electronic management controls and procedures which are to revolutionize the business world of tomorrow.

The Remington Rand Univac, with its cost-cutting speed, gives management the facts it needs *when* it needs them. And, with Univac's unique accuracy, management knows those facts are right!

Find out how U. S. Steel and other typical users have put Univac to work on virtually all types of commercial data-processing. We'll be happy to send EL135—an informative, 24-page, 4-color book on the Univac System—to business executives requesting it on their company letterhead. Send your requests to Room 2106, 315 Fourth Avenue, New York 10, New York.

*Registered in the U. S. Patent Office

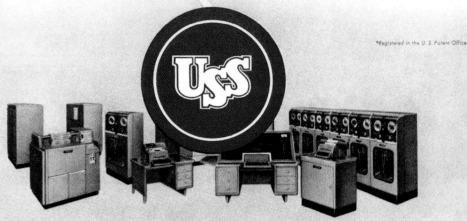

Remington Rand Univac

Makers of: Univac I • Univac II • Univac Scientific • Univac File-Computer • Univac 60 • Univac 120 • Univac High-Speed Printer

DIVISION OF SPERRY RAND CORPORATION

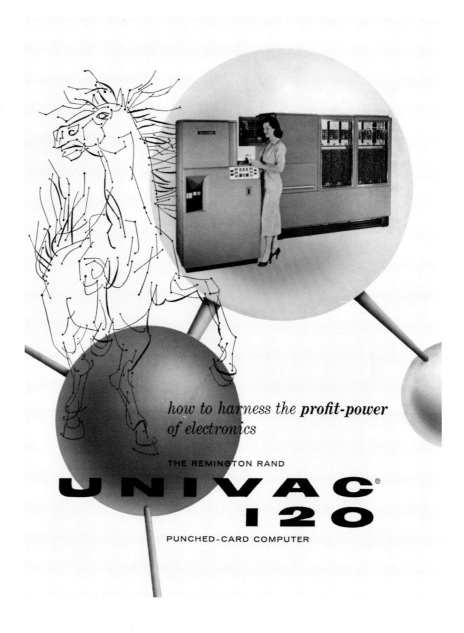

how to harness the **profit-power** of electronics

THE REMINGTON RAND

UNIVAC® 120

PUNCHED-CARD COMPUTER

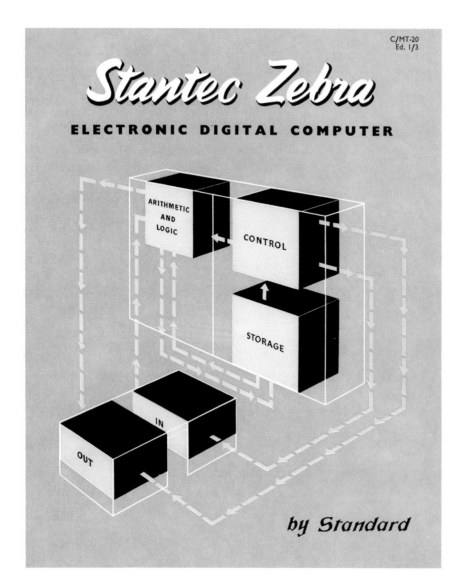

Standard Telephones and Cables,
Limited, 1957 *(left)*

IBM, 1955 *(opposite)*

IBM
TRADEMARK

705 · EDPM

ELECTRONIC DATA PROCESSING MACHINE

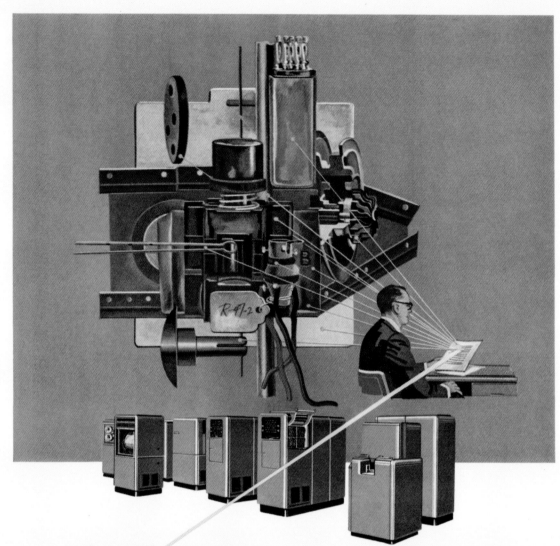

Univac® File-Computer...*"No Other Inventory Records Needed!"*

The UNIVAC File-Computer brings to management a totally new concept of electronic fact-power — random access to large volumes of data, with on-line input and output ... faster than any comparable system! Up-dates your business records *automatically*.

Result: With inventory records, for example, part number, pieces on hand, pieces on order, and a model usage code can all be stored in the large-capacity drums of the File-Computer. Additions, deletions, and status reports for any item can then be typed into or out of the computer. With only three or four typists answering inquiries, about 1,000 telephone calls could be processed in a single day. Thus, up-to-the-minute, accurate inventory information is available to all callers at all times. No other records are needed!

This inventory system is just one of the many applications now possible with the UNIVAC File-Computer. Learn how the UNIVAC File-Computer can up-date your business recordkeeping to bring greater speed and efficiency to every phase of your operations. Call your local Remington Rand office or write for TM1090: Room 1616, 315 Fourth Avenue, New York 10, N. Y.

Remington Rand Univac
DIVISION OF SPERRY RAND CORPORATION

Sperry Rand, 1957 *(opposite)*

NCR, 1957 *(right)*

National Cash Register released the Post-Tronic accounting machine in 1956. It became wildly successful with banks due to its magnetic card technology, which translated into fewer mistakes. By 1960, total gross sales of the Post-Tronic reached $100 million, allowing the firm to invest more heavily in its computer systems. This led to the NCR 390—the first low-cost, mass-marketed computer—and a new kind of data storage system, dubbed CRAM (Card Random Access Memory).

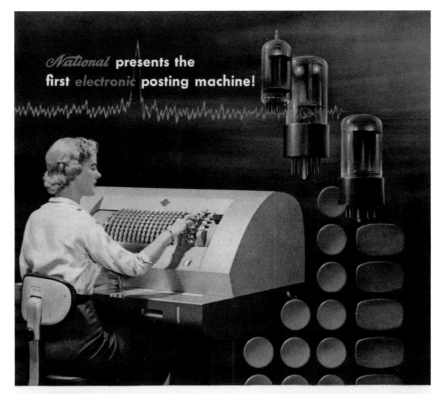

National **presents the first** *electronic* **posting machine!**

National **POST-TRONIC...**
the first electronic bank posting machine!

Now released for sale

The *first* Electronic Posting Machine released for sale is for banks. The National Post-Tronic brings new standards of accuracy — and economy never known before. Through the miracle of Electronics, far more of the posting work is done — without any thought, act or effort by the operator — than can be done by any

present method . . . *far faster*, too! It posts ledger, statement and journal *simultaneously*, all original print (no carbon). It simplifies operator training, and makes the operator's job much easier. And it has many other advantages which, combined with the Electronic features, bring the lowest posting cost ever known. Therefore it will soon pay for itself.

electronically verifies proper account selection
electronically selects correct posting line
electronically picks up and verifies old balance
electronically determines "good" or "overdraft" pickup
electronically picks up and verifies accumulated check count
electronically detects accounts with stop payments and "holds"
electronically picks up, adds, verifies trial balance
electronically picks up, adds, verifies balance transfers
—and what the Post-Tronic does *electronically,*
the operator cannot do wrong!

Your nearby National man will gladly show what your bank can save with the National Post-Tronic.

THE NATIONAL CASH REGISTER COMPANY, DAYTON 9, OHIO
989 OFFICES IN 94 COUNTRIES

National
ACCOUNTING MACHINES
ADDING MACHINES · CASH REGISTERS

Burroughs, 1959 *(left)*

IBM, 1956 *(opposite)*

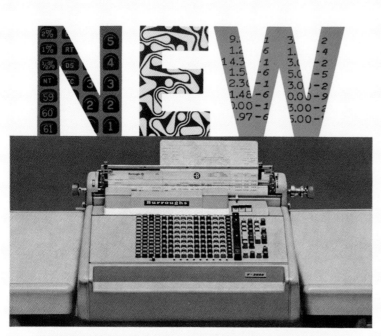

BURROUGHS F-2000 BUSINESS COMPUTER

IT'S A NEW DIMENSION IN COMPUTER / ACCOUNTING MACHINES WITH: DIRECT COMPUTATION · UNLIMITED PROGRAMMING · RELIABLE PRINTED-CIRCUIT COMPACTNESS · 252 DIGIT MEMORY · GANG INPUT · RANDOM ACCESS STORAGE · PRINTED OUTPUT DIRECT TO ACCOUNTING RECORDS · ALL THESE COMPUTER ADVANTAGES AT AN ACCOUNTING-MACHINE PRICE

 Burroughs Corporation
"NEW DIMENSIONS / in electronics and data processing systems"

Call our nearby branch for full details. Or write Burroughs Corporation, Burroughs Division, Detroit 32, Michigan

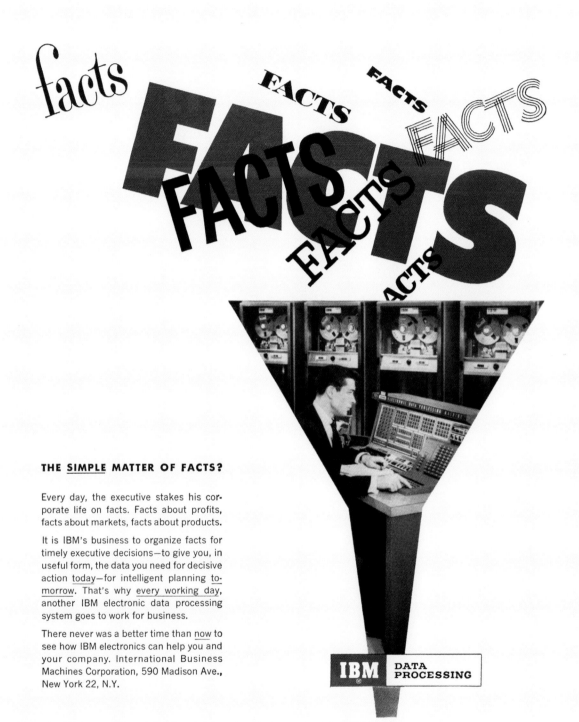

THE **SIMPLE** MATTER OF FACTS?

Every day, the executive stakes his cor-porate life on facts. Facts about profits, facts about markets, facts about products.

It is IBM's business to organize facts for timely executive decisions—to give you, in useful form, the data you need for decisive action today—for intelligent planning to-morrow. That's why every working day, another IBM electronic data processing system goes to work for business.

There never was a better time than now to see how IBM electronics can help you and your company. International Business Machines Corporation, 590 Madison Ave., New York 22, N.Y.

IBM | DATA PROCESSING

DATA PROCESSING ELECTRIC TYPEWRITERS · TIME EQUIPMENT · MILITARY PRODUCTS

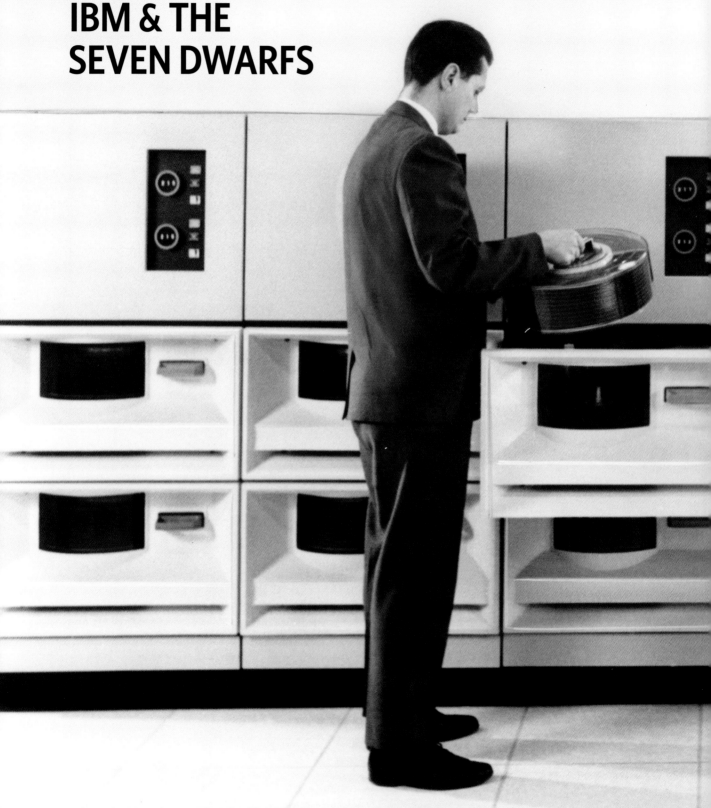

1960–1969
IBM & THE SEVEN DWARFS

1960
The PDP-1 by DEC becomes the first computer to foster creative user interaction.

1960
NAA (North American Aviation) designs the D-17B—a computer to guide its Minutemen missiles.

1961
IBM's 1401 is the latest computer that continues the shift towards evermore accessible machines.

1961
UK-based Ferranti releases the Sirius computer for the compact, everyday office environment.

1962
Wesley Clark and Charles Molnar build LINC, widely considered to be the first personal computer.

1962
The Jetsons debuts on primetime TV portraying a future filled with robots, flying cars, and jetpacks.

1962
The first video game program — *Spacewar!*—is written by Steve "Slug" Russell on a PDP-1.

1963
Ivan Sutherland presents a design program called Sketchpad for his PhD thesis at MIT.

1964
IBM releases the System/360, signaling a new era of innovation, compatibility, and profits.

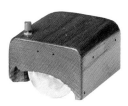

1964
At Stanford, Douglas Engelbart and Bill English create the first mouse, which they call a "bug."

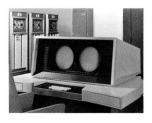

1964
CDC releases the 6600. It will be the world's fastest computer for the next five years.

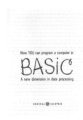

1964
A new programming language called BASIC is designed to make computers more accessible.

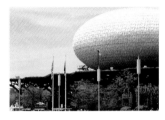

1964
IBM hires Eero Saarinen and the Eames to design its pavilion for the New York World's Fair.

1965
Students at Harvard create one of the first computerized dating services using an IBM 1401.

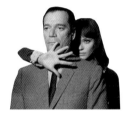

1965
In Jean-Luc Godard's *Alphaville*, an intelligent, God-like computer named Alpha 60 rules the land.

1966
Unimate, an industrial robot, pours a beer on *The Tonight Show Starring Johnny Carson*.

1966
Hewlett-Packard, in existence since 1939, enters the computer market with the 2116A.

1967
Bay Area computer engineers meet at Walker's Wagon Wheel to talk shop.

1967
Honeywell takes a sledgehammer to its DDP-516 system in an effort to display its durability.

1968
Gordon Moore and Robert Noyce found Intel, an abbreviation for "integrated electronics."

1968
In *2001: A Space Odyssey*, an intelligent computer named HAL attempts to murder its crew.

1968
Douglas Engelbart reveals the future of computing with his NLS "online system" demo.

1969
The Apollo Guidance Computer (AGC) plays a crucial role in the first successful moon landing.

1969
UCLA sends a message to Stanford on the ARPANET, an early version of the Internet.

ON-LINE SAVINGS SYSTEM

featuring the

N|C|R 315

with

CRAM

Card Random Access Memory

IBM, 1965 *(pages 74–75)*

NCR, 1960 *(opposite)*

Shockley, ca. 1960 *(right)*

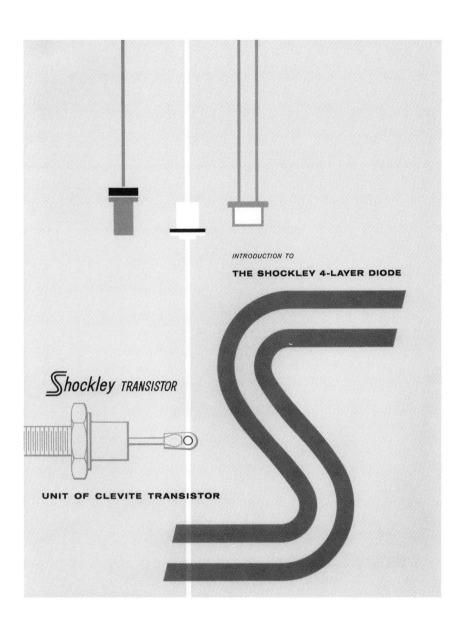

INTRODUCTION TO
THE SHOCKLEY 4-LAYER DIODE

Shockley TRANSISTOR

UNIT OF CLEVITE TRANSISTOR

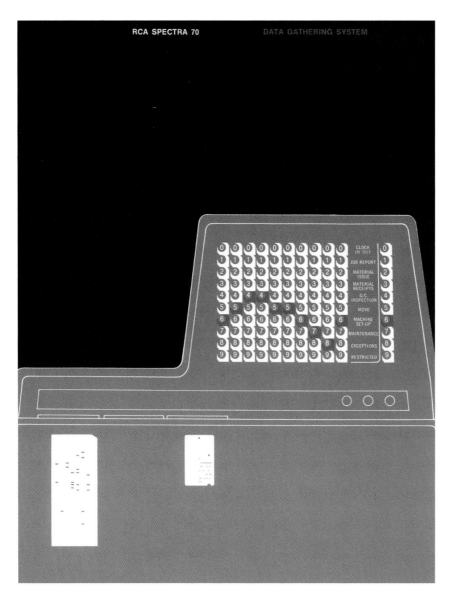

RCA, 1968 *(left)*

Royal McBee, 1961 *(opposite)*

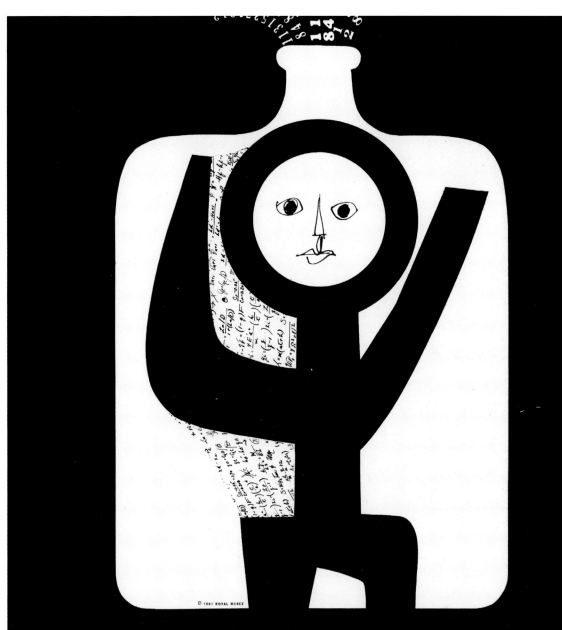

The <u>LGP-30 Electronic Computer</u> begins breaking up figure-work bottlenecks the very same day it is delivered.

The Royal Precision LGP-30 is a complete electronic computer system that is delivered to you ready to go to work. It requires no special personnel. It is simple to program and operate...an engineer can use it himself. It requires no air-conditioning or expensive site preparation. In fact, it requires *no* site preparation. Just roll it to where it's needed and plug it into the nearest convenient 110-volt AC wall outlet. It is desk-size, so it takes little room.

And, though the LGP-30 can solve routine and theoretical math problems 30x faster than any man—it rents for little more than the salary of an additional engineer. Amazing? No, just well-designed, *advanced*. Let us tell you more about it. Write: Mr. Floyd Ritchie, Royal McBee Corp., Port Chester, N. Y.

ROYAL McBEE / **GENERAL PRECISION**
ELECTRONIC DATA PROCESSING SYSTEMS

How much does it cost to press the start button?

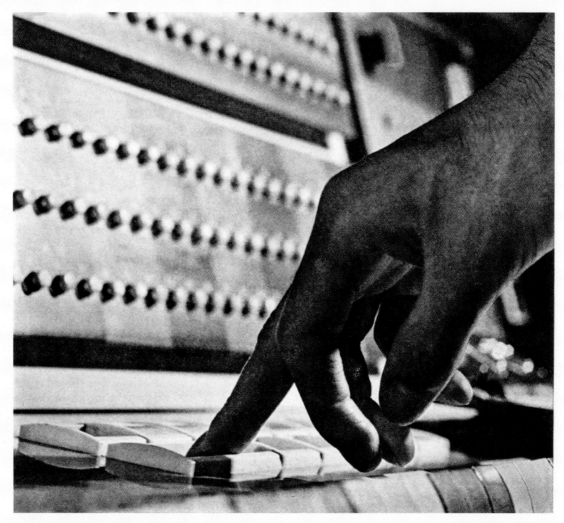

The trouble with a computer is it can't think. You have to tell it exactly how to do a job—step by simple step.

This can get expensive if you have to start from scratch every time you assign a new task to your computer. With an IBM system, you don't have to start from scratch because we provide a lot of the programming you need.

Every IBM system includes programs that tell it how to translate a problem expressed in business or engineering terms into the machine instructions needed to operate the system...how to put

information in and take it out of the system most efficiently...techniques to test for operating accuracy. IBM programming systems save you thousands of dollars when you put a new application on your computer...or switch to a more powerful IBM computer.

Write for publication that tells how IBM programming can cut your programming and data processing costs up to 80 percent. International Business Machines Corporation, Data Processing Division, 112 East Post Road, White Plains, New York. Dept. 805-DF.

IBM DATA PROCESSING

IBM, 1963 *(opposite and right)*

In the early days of IBM, the firm, led by Thomas J. Watson, produced all of its promotional material in-house, fostering a sense of cameraderie among the staff. By the 1960s, it had employed several ad agencies including Marsteller, Rickard, Gebhardt & Reed for its data processing division. Placed in trade magazines such as *Fortune*, a series of elegant ads from 1963 explained in plain language how one could benefit from an IBM.

Now your IBM computer helps in the design of your product...

helps to build it and ship it. All at the same time.

Your IBM computer can handle a lot of the work that chews up an engineer's day. It can check standards, look up constants, multiply, divide, integrate. It can handle routine engineering tasks like these faster than a man...and free him to concentrate on the thinking part of his job (one thing a computer can't do). The designer feeds engineering notations into an IBM data processing system. The system then automatically produces design specifications, bills of material, purchasing, machining and shipping instructions. This saves time—months, on some jobs—helps you get new and improved products into the market place faster. And it cuts down on errors.

Write for booklet that tells how to use an IBM computer in Engineering Data Processing. International Business Machines Corporation, Data Processing Division, 112 East Post Road, White Plains, New York. Department 805-DN.

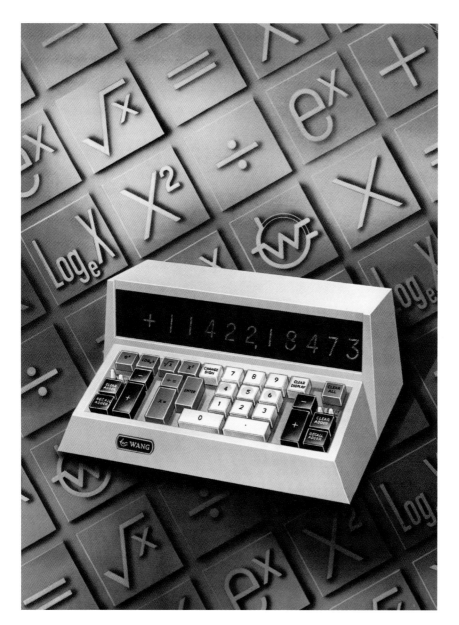

Wang Laboratories, 1968 *(left)*

Wang, known mostly as a producer of high-end calculators throughout the 1960s, commenced developing a general purpose minicomputer in 1968, even though its founder, Dr. An Wang, had already been making a name for himself in the computing industry over a decade prior. As a student at Harvard in the mid-'50s, Wang successfully developed and sold a patent for core memory to industry leader IBM for $500,000, which he then used as seed money to start his own company.

Burroughs, 1964 *(opposite)*

Packard Bell, 1964 *(left)*

IBM, 1963 *(opposite)*

Controlling a business is like controlling a rocket

If you are a business executive, you have the same kinds of problems as the man who controls a rocket launching.

You both have a mass of important information to keep track of and little time to do it. You both need to spot trouble before it starts—and act to prevent it.

The rocket man worries about fuel consumption, speed, trajectory. You worry about sales, production, purchasing, financing, shipping costs.

You both need facts in a hurry—important, pertinent facts—while they are still fresh and while there is still time to use them to solve problems.

The rocket man solves many of his information problems with IBM Systems. The same systems and techniques are available to you, right now, from IBM.

DATA PROCESSING

Operating System
Orientation for
Management

Honeywell, 1966 *(opposite)*

DEC, 1961 *(right)*

The PDP-1 broke the mold: it was much smaller and considerably less expensive than other computers on the market, but more importantly it encouraged user interaction. The manufacturer, DEC, donated one to MIT in 1961 and it became a blank canvas on which a budding hacker culture wrote programs for a variety of applications. In 1962, a hacker named Steve "Slug" Russell wrote the world's first video game program—*Spacewar!*—on a PDP-1.

PROGRAMMED DATA PROCESSOR-1

RANDOM-SEQUENTIAL COMPUTER SYSTEM

NCR, 1960 *(opposite)*

Philco, 1963 *(right)*

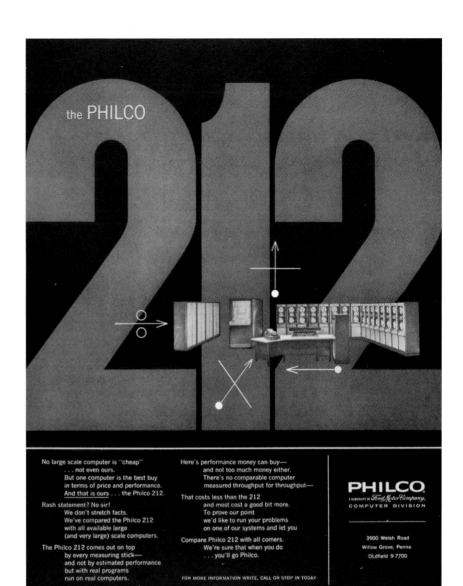

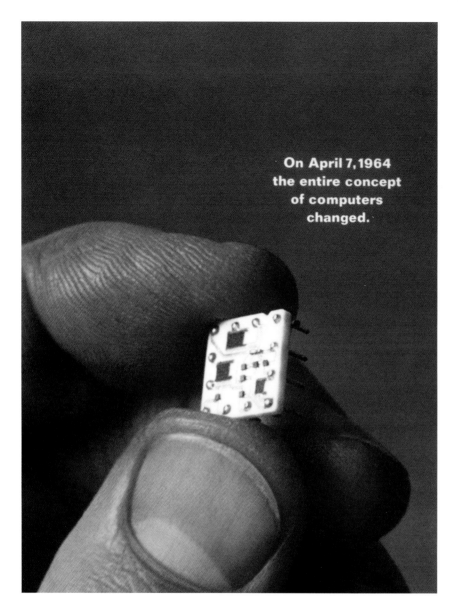

On April 7, 1964
the entire concept
of computers
changed.

IBM, 1964 *(left)*

Computer Terminal Corporation,
1969 *(opposite)*

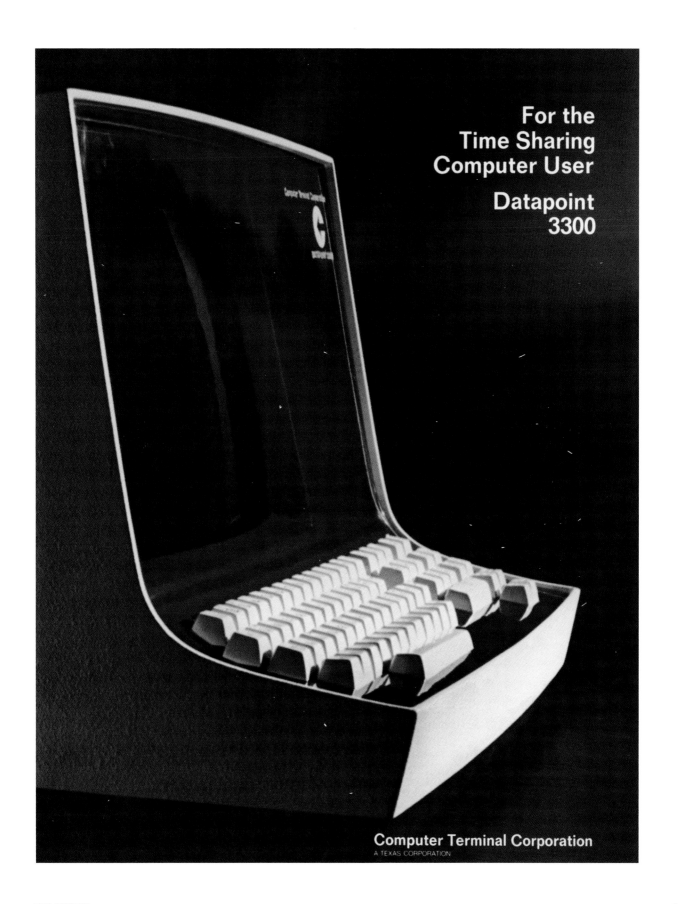

For the
Time Sharing
Computer User

Datapoint
3300

Computer Terminal Corporation
A TEXAS CORPORATION

Computer Terminal Corporation, 1969 *(left)*

RCA, 1966 *(opposite)*

RCA SPECTRA▽70|45

the medium-scale computer for big workloads

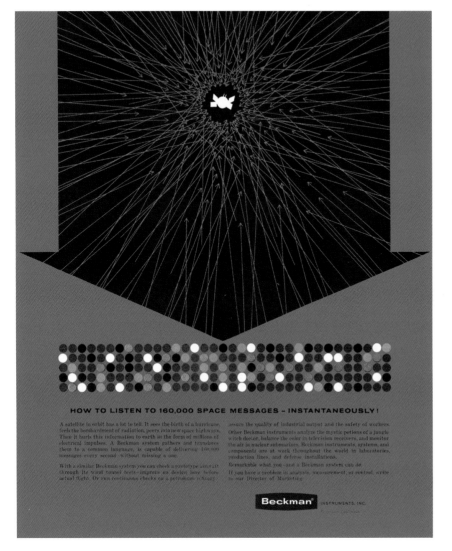

HOW TO LISTEN TO 160,000 SPACE MESSAGES – INSTANTANEOUSLY!

Beckman INSTRUMENTS, INC.

Sperry Rand, 1965 *(pages 96–97)*

Beckman Instruments, 1962 *(left)*

Beckman, a biomedical lab equipment firm, entered the computer market in 1955 when it hired William Shockley to run a new division of the company focused on semiconductors (such as silicon). The brilliant but erratic Shockley alienated his employees to the point where eight of them broke away to form their own company, dubbed Fairchild Semiconductor. "The traitorous eight," as they came to be known, went on to do some of the most important and influential work on semiconductors in the burgeoning Silicon Valley.

Beckman Instruments, 1961 *(opposite)*

A SINGLE DROP OF BLOOD CAN SAVE YOUR LIFE

Precious little blood can sometimes be spared for clinical testing. A baby, a burn victim, an older person. With Beckman instruments, you can perform vital analyses with the smallest samples. Even a drop.

With Beckman instruments you can unveil the subtle allure of a Paris perfume. You can track down the killer in rattlesnake venom. You can unscramble a puff of smoke.

Other Beckman instruments measure the acidity or alkalinity of the foods you eat. Or monitor smog and identify its contaminants. Or guide a space vehicle and record its sensations. Beckman instruments, systems, and components are at work throughout the world in laboratories, production lines, and defense installations.

Remarkable what you – and a Beckman instrument can do.

If you have a problem in analysis, measurement, or control, write to our Director of Marketing.

 Beckman® INSTRUMENTS, INC.
Fullerton, California

From advanced technology available today!

Cyclotron computations handled 30 times faster on Michigan State University CONTROL DATA® 3600

When Michigan State's 50-million volt Cyclotron is completed this year, a CONTROL DATA 3600 Computer system will analyze *all* of its experiments. Presently the 3600 is analyzing the Cyclotron's design and doing it 30 times faster than MSU's former computer. Such high speed is enabling MSU to meet the increasing demand of its departments for computer time. Besides wrapping up Cyclotron work, the 3600 is today assisting researchers in the fields of physical and biological sciences as well as in psychology, sociology, education, communications, economics and government.

The "3600" is the fastest, most versatile computer now in operation. It provides a man/ machine research partnership that can solve large scale scientific problems at very high speeds. CONTROL DATA serves science and research throughout the world — hardware, software, supportive aid, all oriented to the particular user and his methods. For an exploration of specific computer systems, contact your nearest CONTROL DATA representative or write to our Minneapolis address, Dept. F94.

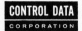

CONTROL DATA
CORPORATION
8100 34th Ave. S., Mpls., Minn. 55420

New MSU 3600 computer system (East Lansing, Mich.)

- A CONTROL DATA 3600 computer with 32,000 words of core memory
- A CONTROL DATA 160-A computer used as a satellite processor for input/output work
- 8 CONTROL DATA 606 magnetic tape transports (soon to be expanded to 10)
- A CONTROL DATA 405 card reader
- A CONTROL DATA 501 high speed line printer capable of printing nominally 1,000 consecutive lines per minute and 136 characters per column
- A CONTROL DATA remote keyboard to be added in the near future

H316
General Purpose
Digital Computer

Honeywell

a
molecular
electronic
computer
by ti

Texas Instruments, 1961
(opposite)

NCR, 1960 *(right)*

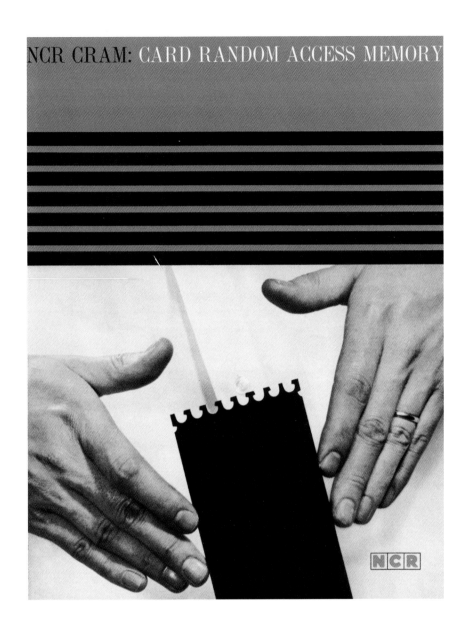

NCR CRAM: CARD RANDOM ACCESS MEMORY

IBM , 1964 *(above left)*

Burroughs, 1962 *(above right)*

Sperry Rand, 1965 *(opposite)*

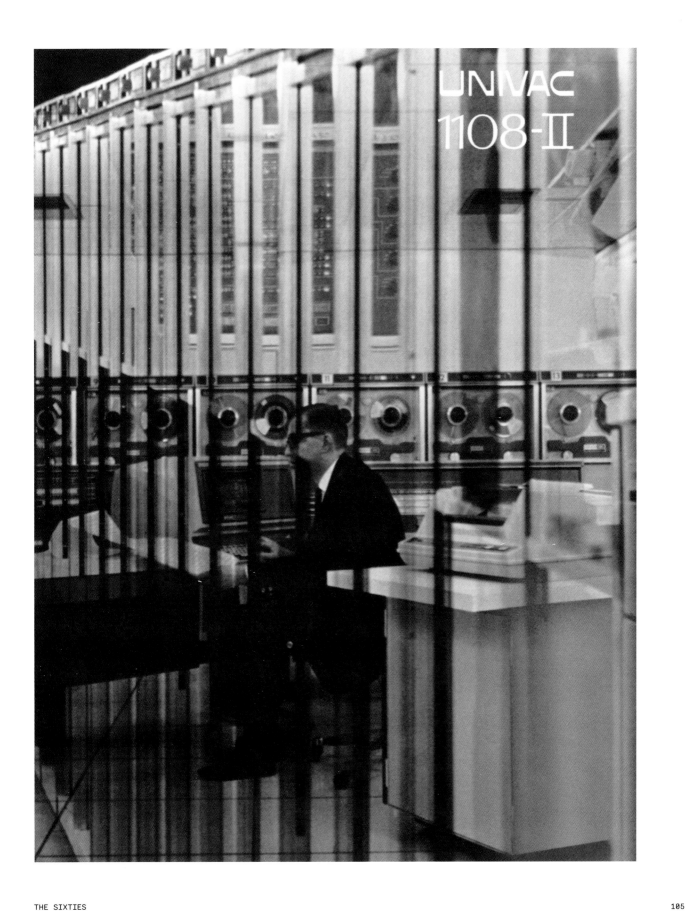

Burroughs, 1963 *(opposite)*

In terms of market share, Burroughs was far behind the 800-pound gorilla known as IBM, but thanks in part to an artful series of ads throughout the '60s, the Detroit-based company carved out a niche for itself among small businesses including banks and retailers. Here, the image of the computer is small compared to a bright, somewhat naïve illustration of shoes — a calculated human touch meant to soothe doubts about this hulking piece of machinery.

Underwood-Olivetti, 1962 *(right)*

underwood Research prompted by creative intelligence is the source of every invention, and in this process numbers have an essential role. Every day the challenge of progress demands more accurate figure-facts. Underwood has answered the challenge with a line of computing machines that print all terms and results for verification and reference. Each Underwood-Olivetti machine is distinguished by design that reflects its functional perfection.

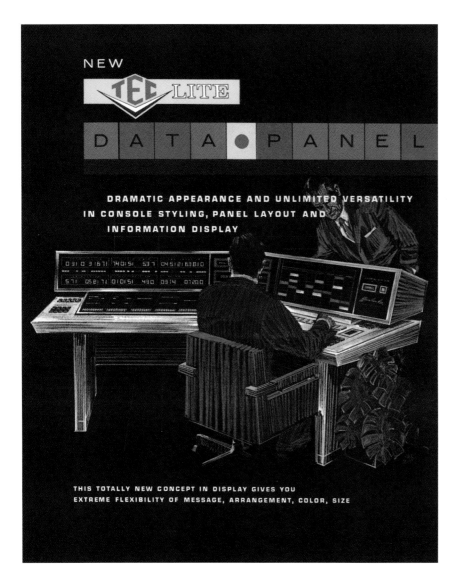

TEC, 1964 *(left)*

Honeywell, 1968 *(right)*

SDC

How can swarms of supersonic airliners be kept safe from collisions? How can your doctor correlate thousands of case histories quickly to find the optimal treatment for your illness? How can a vast military system react instantly and correctly to any threat? The solution of these problems requires large control systems. This is the work of SYSTEM DEVELOPMENT CORPORATION—a non-profit organization charged with developing large-scale control systems for military, scientific, and industrial operations. It employs operations research scientists, computer programmers, analytical engineers, human factors scientists, and others with diverse professional backgrounds. Professional staff openings are at Santa Monica, California and Lodi, New Jersey.

less time to control **more things**

System Development Corporation, 1960 *(opposite)*

General Electric, 1965 *(right)*

In the 1960s, anyone who wanted to use a computer had to know how to program it. This was fine for the engineers, computer scientists, and hobbyists who enjoyed the process of hacking, but was impenetrable to most others. In 1964 at Dartmouth, Thomas Kurtz and John Kemeny, a former assistant to Albert Einstein, invented the BASIC programming language to make the school's computer accessible to its liberal arts students. Its ease of use made it an industry standard for decades.

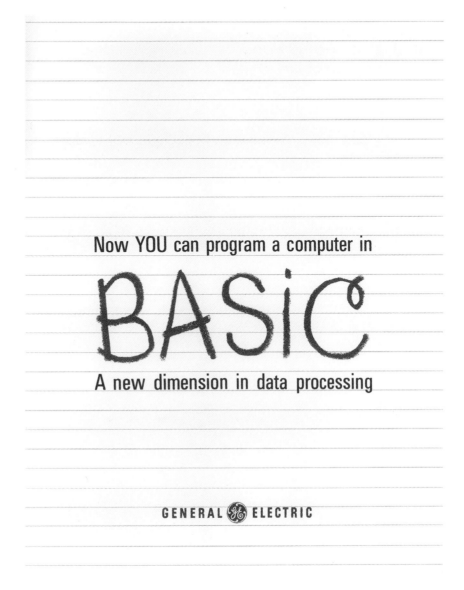

Now YOU can program a computer in

BASIC

A new dimension in data processing

GENERAL ⚙ ELECTRIC

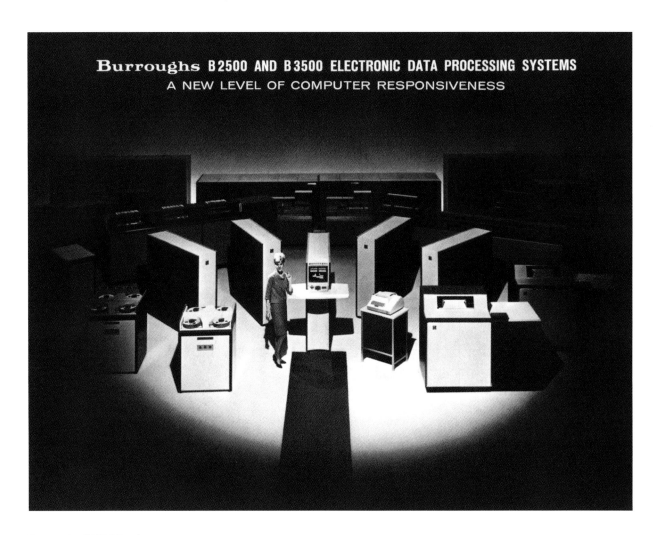

Burroughs, 1965 *(above)*

Burroughs, 1962 *(opposite)*

WE'D LIKE TO PUNCH A THEORY FULL OF HOLES FOR YOU! THIS ONE:

ONLY BIG COMPANIES CAN AFFORD TO ENJOY ALL THE SPEED AND WORK SAVING ADVANT- AGES OF A COMPUTER!

If your company is large enough to use an adding or accounting machine then it's also large enough to take advantage of computer processing—and here's how: ■ *With a Burroughs punched tape adding or accounting machine, you get a punched tape record of all your accounting data for processing at a computer center. The tape is created as an automatic by-product of your regular accounting operation, right along with the usual printed record. Your operator needs no retraining and your accounting setup remains exactly as is. And you now get all the advantages of computer processing:* ■ *Fully detailed reports and analyses that clearly highlight all pitfalls and promising trends. New insights that will help you save or make enough money to repay the cost of your Burroughs punched tape equipment over and over again.* ■ *Our local branch office or your nearby independent data processing center can give you all the details. Burroughs Corporation, Detroit 32, Michigan.* Burroughs—TM

Burroughs Corporation

9200
low cost, internally
programmed
with direct
access discs
and communications

9300
versatile, next-step-up
tape and disc system
with concurrency
and communications

9400
high performance,
medium scale system
with multiprogramming
and real-time
communications
capabilities

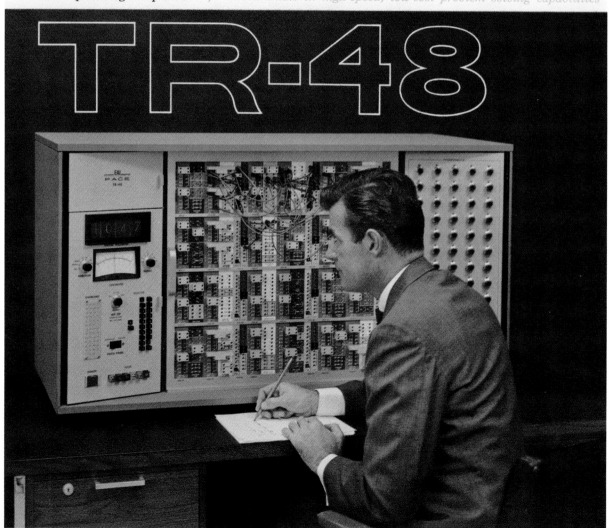

TR-20

desk top analog computers... *for the ultimate in high-speed, low-cost problem solving capabilities*

TR-48

Sperry Rand, ca. 1969
(pages 114–115)

Electronic Associates, 1964
(opposite)

NCR, 1965 *(right)*

How long would it take us to show you the advantages of the new 315 RMC Rod Memory Computer?

About 800 billionths of a second.

Because its entire main memory is made up of thin wire rods plated with a magnetic thin film that permits cycle speeds of 800 nanoseconds (800 billionths of a second). That memory, incidentally, has a capacity of up to 240,000 digits.

Also available for this new 315 RMC — and all 315's — is a new line of faster and more efficient peripherals, such as: speedier tape drives (66 KC conversion of data from other computers and 120 KC for direct processing); a 1000 line-per-minute printer; a 250-cpm card punch; a data communications controller for "on-line" applications; built-in floating point arithmetic; new high capacity CRAM III (Card Random Access Memory) that has up to 16,000,000 characters of random access storage in each CRAM cartridge.

The 315 RMC is completely compatible with all existing 315 peripheral equipment. All 315 programs and software, including NEAT, COBOL and the recently announced program generator BEST may be run—as is.

Deliveries begin in mid-65. For more information about the versatile 315 family of computers (and, especially, the new 315 RMC), call your local NCR office. Or, write to NCR, Dayton, Ohio 45409.

BE SURE TO VISIT THE NCR PAVILION AT THE NEW YORK WORLD'S FAIR THE NATIONAL CASH REGISTER COMPANY ®

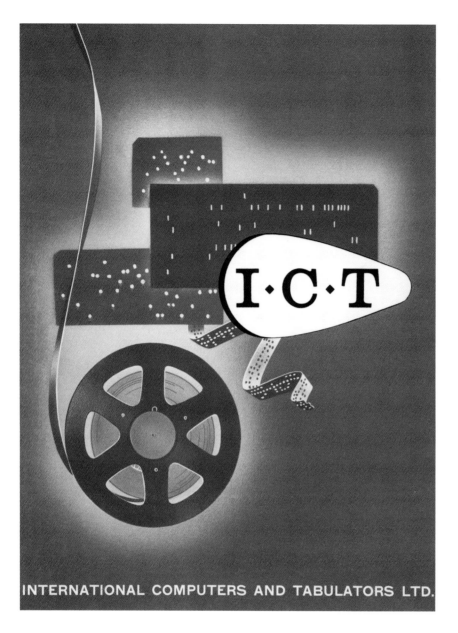

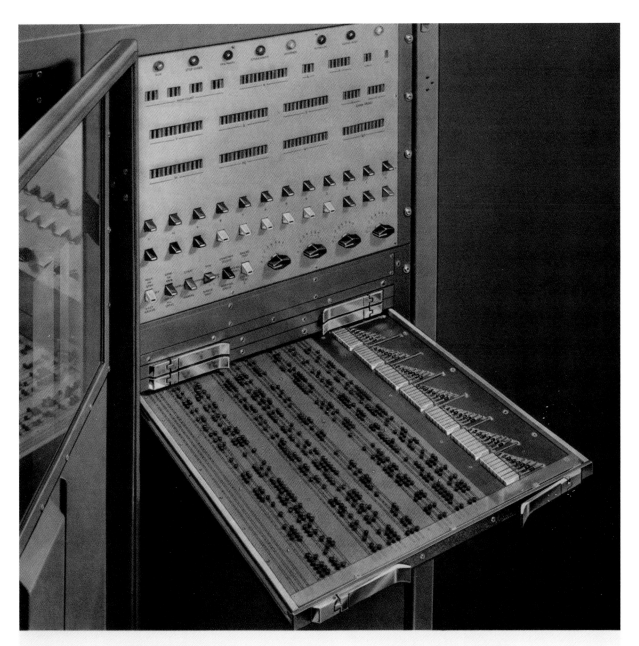

FERRANTI ARGUS

Process-Control Computer System

LIST DC.39C JANUARY, 1961

Ferranti, 1960 *(left)*

Transitron, 1960 *(opposite)*

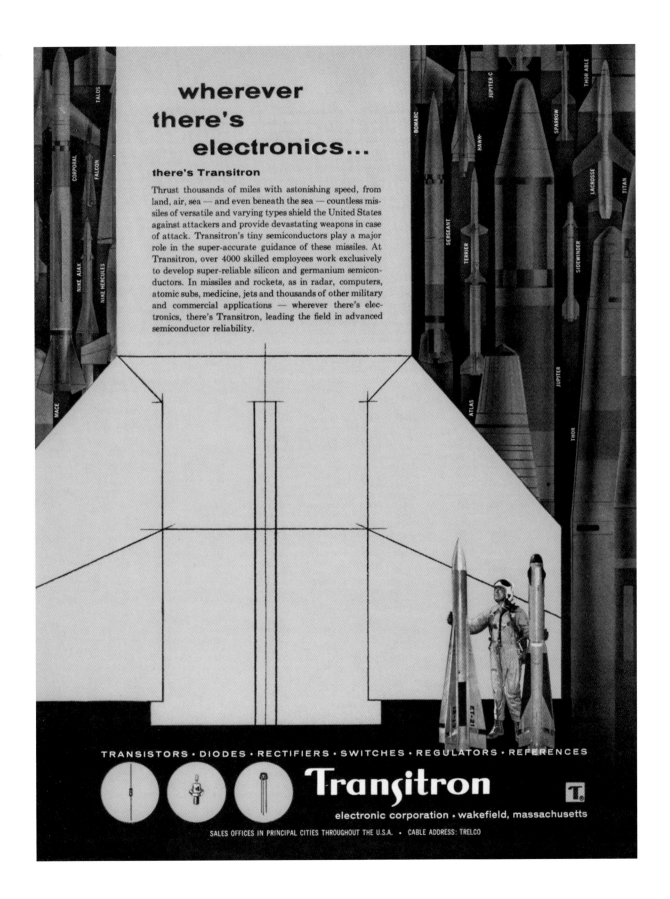

We read and write <u>your</u> business language and translate it into savings

Today, integrated A-M methods transmit vital business information faster, regardless of the "language" or system you use. It may be via Addressograph® metal or plastic plates or bar code. It may be "just plain English" reproduced by Multilith® masters. Or MICR type, punched cards, paper tape, or the impulses of magnetic tape. ■ One example: the strange-looking numbers on the checks you carry were probably imprinted in magnetic ink by Multilith Offset — reducing posting errors, saving hours of clerical time. Another: that Addressograph credit card you use to buy gasoline imprints bar code right on the sales slip. It's then "read" by an Addressograph electronic scanner at central processing headquarters . . . feeding accurate data direct to accounting. Costs cut again! ■ A-M equipment also extends the savings of computers and other high speed data processing installations. It helps break the input bottleneck, multiplies output to speed communication — makes such installations really pay off! ■ Talk to your nearby A-M representative about how modern A-M methods can translate <u>your</u> business language into new savings.

Addressograph - Multigraph Corporation

MAIN OFFICE: 1200 BABBITT ROAD, CLEVELAND 17, OHIO • BRANCH OFFICES IN PRINCIPAL CITIES OF THE WORLD

presenting a totally different concept in electronic data processing

AM SERIES 900 edp SYSTEM

A-M, 1962 *(opposite)*

A-M, ca. 1961 *(above)*

IBM, 1964 *(above)*

Hitachi, 1969 *(opposite)*

 HITAC 10

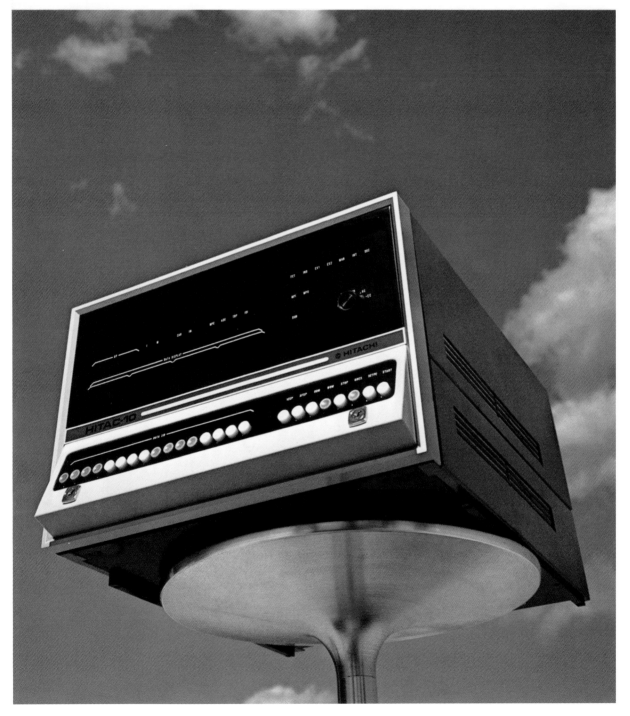

1970–1979
COMPUTERS
GET PERSONAL

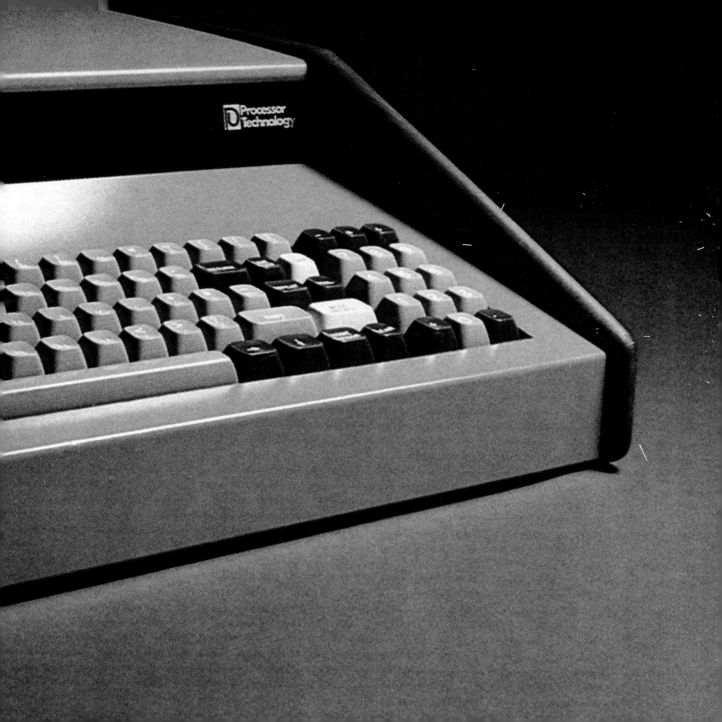

1970

Stanford's Shakey is proclaimed the "first electronic person" by *LIFE* magazine.

1971

Computer Space is the original mass-produced, coin-operated arcade video game.

1971

Intel's 4004 microprocessor chip paves the way for a "new era in integrated electronics."

1971

Hewlett-Packard releases the HP-35, a "shirt pocket-sized" version of its desktop calculator.

1971

Ray Tomlinson builds an email system on ARPANET, initiating the use of the at sign.

1972

"Ready or not, computers are coming to the people," declares Stewart Brand in *Rolling Stone*.

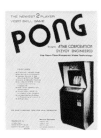

1972

Newly-formed Atari releases a 2-D arcade game based on table tennis called *Pong*.

1973

Magnavox releases a video game system inspired by the Brown Box called the Odyssey.

1973

The Alto, created at Xerox's Palo Alto Research Center, anticipates the "office of the future."

1974

Radio-Electronics magazine features a kit computer on the cover—the Mark-8.

1974

An ad appears in *QST* magazine for a build-it-yourself computer called the Scelbi-8H.

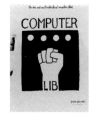

1974

Computer Lib/Dream Machines is published by Theodor Nelson, serving as a bible for hobbyists.

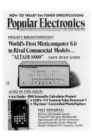

1975
A kit computer called the Altair appears on the cover of *Popular Electronics*. Sales boom.

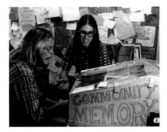

1975
The Community Memory project at Leopold's Records in Berkeley seeks to democratize technology.

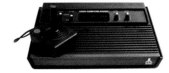

1975
Atari moves from arcade video games to living rooms with the VCS (Video Computer System).

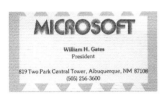

1975
Microsoft is established by 20-year-old Bill Gates and his high school friend, Paul Allen.

1975
The new MOS Technology 6502 microprocessor chip sells for a mere $25. Hobbyists rejoice.

1976
Steve Jobs and Steve Wozniak sell their personal belongings to launch the Apple I.

1976
Lee Felsenstein's Sol-20 is a work of art with its sleek blue shell and walnut side panels.

1977
The Apple II seeks to bridge the gap between the hobbyist crowd and the average consumer.

1977
Commodore releases the PET 2001 line of personal computers starting at only $595.

1977
Completing the "1977 Trinity" of personal computers, Tandy/Radio Shack unveils the TRS-80.

1978
A marketer at DEC sends an ad to hundreds of people at once on the ARPANET, pioneering spam.

1978
Atari throws its hat in the ring of the personal computer market with the 400 and 800 systems.

Processor Technology, 1977
(pages 126–127)

Zilog, 1979 *(left and opposite)*
Illustration by Lou Brooks

A marketing brochure in the form of a comic book, *Captain Zilog!* tells the story of systems designer Nick Stacy, who gets pulled through his CRT screen one night by a God-like force called "Opportunity," who bestows on him the superpower of a microprocessor, transforming him into Captain Zilog. Nick must save the citizens of Cityville from one Dr. Diabolicus, who rules the universe with "the largest and most complex computers in the universe."

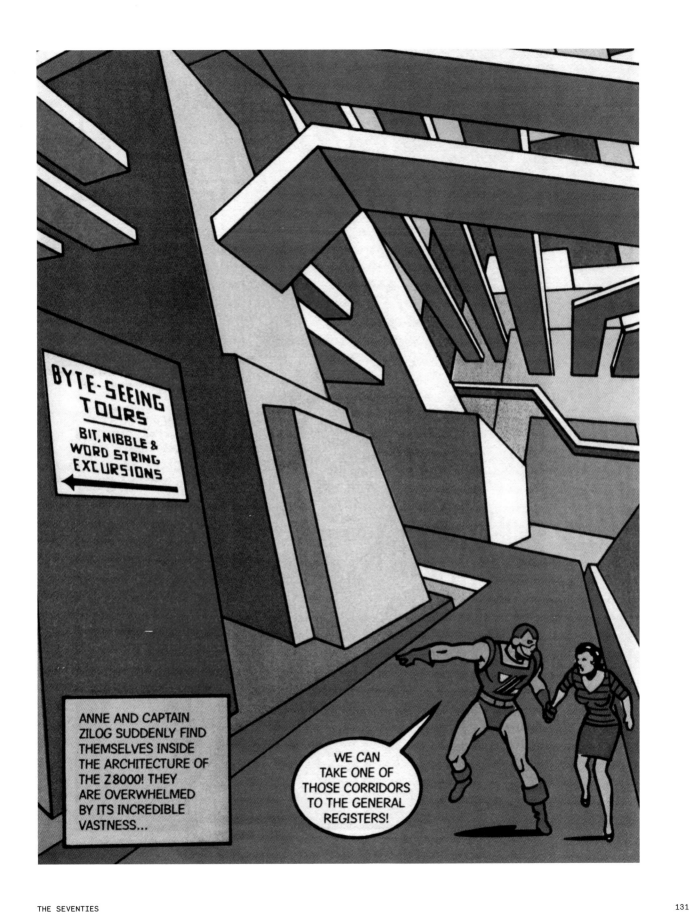

Tektronix, 1976 *(opposite)*

Hewlett-Packard, 1972 *(right)*

Hewlett-Packard was started by two Stanford students in Palo Alto in 1939. Originally conceived as an instrumentation company, one of its early customers was Walt Disney, who purchased audio oscillators for his animated feature *Fantasia*. HP's first computer was the 2116A, which was developed for internal product testing purposes. However, it soon became clear that there was a large potential market for data processing machines, resulting in an expansion of its 2100 product line.

Processor description

HEWLETT PACKARD 2100

HEWLETT **hp** PACKARD

HEWLETT hp PACKARD

9701A/B
**Distributed
Systems**

Hewlett-Packard, 1973
(left)

Lockheed Electronics, 1970
(opposite)

Software

Lockheed Electronics

Software

Lockheed Electronics

MAC 16

SYSTEM B
$4,495.00

40K Bytes RAM Memory
1,200,000 Bytes Disk Storage
Desk with laminated plastic surface
DOS and BASIC with random and sequential files
TERMINAL—Upper-Lower case and full control character decoding

SOUTHWEST TECHNICAL PRODUCTS CORPORATION
219 W. RHAPSODY
SAN ANTONIO, TEXAS 78216

Circle 350 on inquiry card.

The Computer for the Professional

Whether you are a manager, scientist, educator, lawyer, accountant or medical professional, the System 8813 will make you more productive in your profession. It can keep track of your receivables, project future sales, evaluate investment opportunities, or collect data in the laboratory.

Use the System 8813 to develop reports, analyze and store lists and schedules, or to teach others about computers. It is easily used by novices and experts alike.

Reliable hardware and sophisticated software make this system a useful tool. Several software packages are included with the machine: an advanced disk operating system supporting a powerful BASIC language interpreter, easy to use text editor, assembler and other system utilities. Prices for complete systems start at $3250.

See it at your local computer store or contact us at 460 Ward Dr., Santa Barbara, CA 93111, (805) 967-0468.

PolyMorphic
Systems

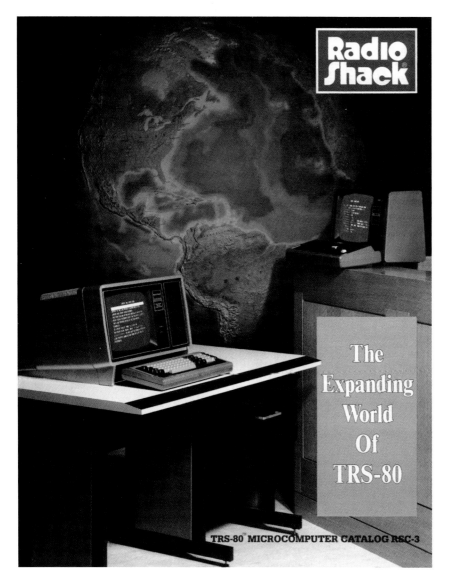

The Expanding World Of TRS-80

TRS-80® MICROCOMPUTER CATALOG RSC-3

SWTPC, 1978 *(page 136)*

PolyMorphic Systems, 1977 *(page 137)*

Tandy, 1977 *(left and opposite)*

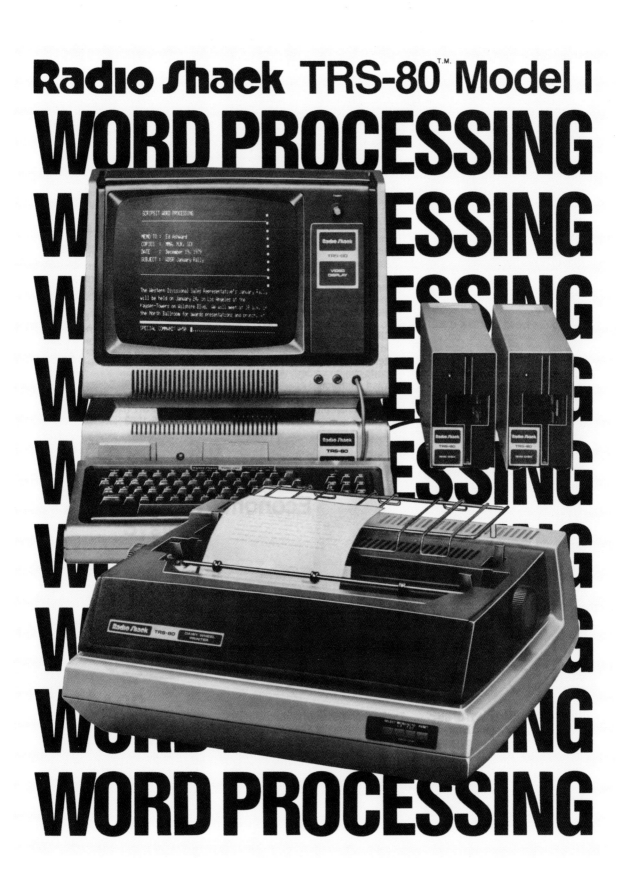

FOX 1
software

fastware

FOXBORO

Foxboro, 1971 *(above)*

Cincinnati Milacron, 1970
(opposite)

CINCINNATI
MILACRON

DEC, 1970 *(opposite)*

Data General Corporation,
1970 *(right)*

MITS, 1976 *(left)*

Widely regarded as the moonshot of the personal computer revolution, the Altair appeared on the cover of *Popular Electronics* in January 1975 and resulted in such a feeding frenzy that its creator, Ed Roberts, couldn't fulfill orders fast enough. Among its admirers were two college students by the name of Paul Allen and Bill Gates, who asked Roberts if they could write software for the new system. After working with MITS for a brief stint, the dynamic duo left to establish their own company, calling it Micro-Soft.

Computer Automation, 1971 *(opposite)*

NAKED MINI/ALPHA 16

NET/ALERT™
The TP performance spotlight ™

BECAUSE YOU SHOULDN'T
LEARN ABOUT YOUR
TP NETWORK PROBLEMS
FROM YOUR USERS

AVANT-GARDE
Computing, Inc.

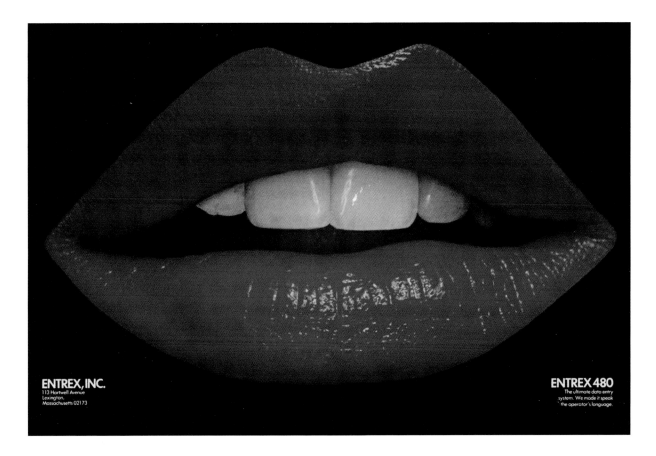

Avant-Garde Computing,
1970 *(opposite)*

Entrex, ca. 1975 *(above)*

The data-base access system of the 70's

Four-Phase Systems, 1970
(opposite)

Sperry Rand, ca. 1978 *(right)*

SPERRY UNIVAC
Series V77 Minicomputer Systems
Power, Performance, Productivity

POWER.

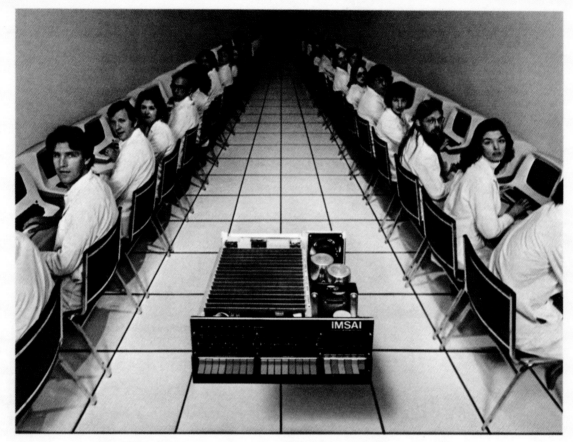

IMSAI Introduces the Megabyte Micro.™

IMSAI, 1977 *(above)*

Hitachi, 1971 *(opposite)*

Thinking robot developed by Hitachi

Power Generation & Transmission Equipment

Industrial Machinery

Transportation Equipment

Communications Equipment

Electronics & Home Appliances

Many robots act like they're smart. But actually everything they do is programmed into them in advance by their human masters.

Not so with Hitachi's smart new HIVIP Mk.1, a robot with a mind of its own. One of the two TV cameras that serve as its eyes can scan a three-part two-dimensional projection of a solid object and feed what it sees into its brain, a HITAC 7250 digital computer. Here our intelligent robot conceptualizes the object in its full three-dimensional form and analyzes its structure. Another TV camera acts as his second eye. It scans a number of objects and identifies the ones which it has previously created an image for.

Now comes the action. The robot decides how best to assemble the pieces into the required form. And proceeds to do so with its claw-like mechanical hand.

Although HIVIP Mk.1 is only a prototype, it is easy to see how more sophisticated models will be trained to work in assembly lines, quality control, baggage handling, and other tasks requiring precise judgment and handling.

Only the future will reveal what miracles research and development can accomplish.

We at Hitachi are dedicated to the pursuit of new knowledge through research—not only in computer-controlled robots but in other areas as well—so that we may contribute our share toward the building of a better world for all.

HITACHI

A
MICRO
PROGRAMMABLE
TERMINAL
from
The House of Beehive

SUPER BEE

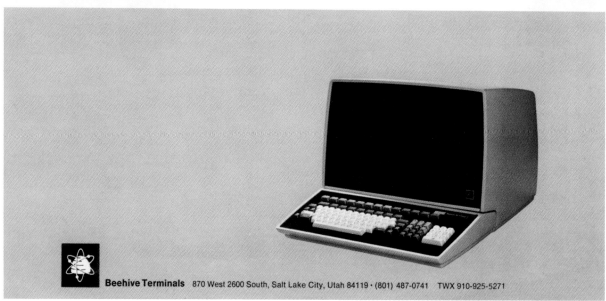

Beehive International, 1978
(opposite)

The Super Bee, a terminal with a detachable keyboard, was sold by Salt Lake City firm Beehive International. It was marketed as an "intelligent" monitor by virtue of its microprocessor, allowing it to be compatible with a variety of applications. The firm's logo is a reference to Utah's state emblem of the beehive, which symbolizes productivity and industry.

Tektronix, 1974 *(right)*

We've got the first low·priced big screen.

But you haven't seen anything yet.

System/370
Virtual Machine Facility/370

IBM

IBM, 1973 *(left)*

IBM continued its dominance of the mainframe computer market well into the '70s. The vibrant and stylish cover for its 370 computer conveys a youthful exuberance, but with a price tag of approximately a quarter of a million dollars (which translates into roughly $1.5 million today) those who could purchase this machine were limited to large businesses and corporations. It was, in part, this long-standing culture of exclusivity that fueled hobbyists to figure out a way to make computers accessible to everyone.

Xerox, 1973 *(opposite)*

XEROX

Diablo HyType I

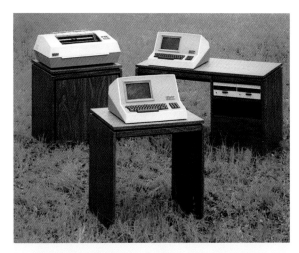

SYSTEMS - SOLUTIONS

If you have a problem that can be solved by a computer—we have a systems solution.

- Two central processors with maximum RAM capacities of 56K and 384 K bytes
- Three types of disk drives with capacities of 175K, 1.2M and 16M bytes
- Two dot matrix printers with 80 and 132 line capacity
- A Selectric typewriter interface and a daisy wheel printer

Match these to your exact need, add one or more of our intelligent terminals and put together a system from one source with guaranteed compatibility in both software and hardware.

Southwest Technical Products systems give you unmatched power, speed and versatility. They are packaged in custom designed woodgrain finished cabinets. Factory service and support on the entire system and local service is available in many cities.

SOUTHWEST TECHNICAL PRODUCTS CORPORATION
219 W. RHAPSODY
SAN ANTONIO, TEXAS 78216 (512) 344-0241

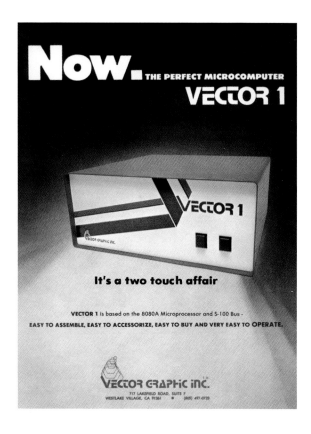

Now. ■ THE PERFECT MICROCOMPUTER
VECTOR 1

It's a two touch affair

VECTOR 1 is based on the 8080A Microprocessor and S-100 Bus -

EASY TO ASSEMBLE, EASY TO ACCESSORIZE, EASY TO BUY AND VERY EASY TO OPERATE.

VECTOR GRAPHIC INC.™
717 LAKEFIELD ROAD, SUITE F
WESTLAKE VILLAGE, CA 91361 ■ (805) 497-0733

Both sides now

North Star Announces —
Double Density x 2 Sides = Quad Capacity!

The North Star Horizon now delivers quad capacity by using two-sided recording on our new mini drives! That's 360,000 bytes per diskette! A four drive North Star system accesses over 14 megabytes of information on-line! Think of the application flexibility that so much information storage can give you!

North Star has quadrupled the disk capacity of the Horizon computer but prices have increased a modest 15 percent. On a dollar per byte basis, that's a bargain that is hard to beat!

The proven North Star disk controller was originally designed to accommodate the two-sided drives. North Star DOS and BASIC are upgraded to handle the new capacity, yet still run existing programs with little or no change. Of course, single sided diskettes are compatible with the new disk system.

North Star Horizon Computer Prices (with 32K RAM):

Horizon-1-32K-Q	$2349
Horizon-2-32K-Q	$2999
Horizon-1-32K-D	$2099
Horizon-2-32K-D	$2549

Get both sides now! Quad capacity is available from your North Star dealer.

NorthStar
North Star Computers
2547 Ninth Street
Berkeley, CA 94710
(415) 549-0858 TWX/Telex 910-366-7001

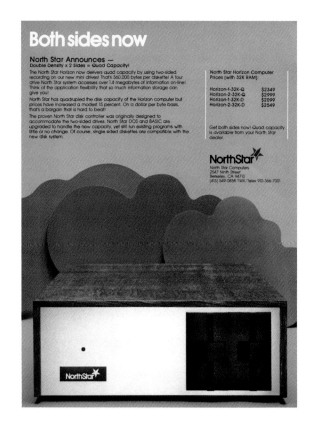

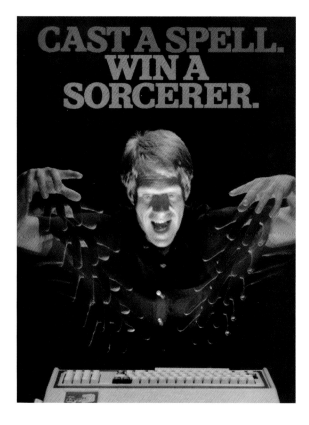

CAST A SPELL. WIN A SORCERER.

SWTPC, 1979
(opposite top left)

Vector Graphic, 1977
(opposite top right)

Exidy, 1979
(opposite bottom right)

North Star, 1979
(opposite bottom left)

Apple, 1977 *(removed)*

Apple II was part of the "1977 Trinity" of PCs—low-cost and easy-to-use systems that were geared towards individuals as opposed to businesses. Though the Altair had been on the market for a few years, it only caught on with hobbyists due to the considerable amount of tinkering it required as well as its techie appearance. The Apple II, on the other hand, felt like something that could be placed in your kitchen alongside the toaster oven or microwave.

Editor's note: Apple respectfully declined to be included in the book. Given the importance of Apple to computer history, not to mention computer advertising, we decided to leave the caption for the Apple II in place. Subsequent chapters will not feature any blank pages, although Apple advertisements were removed from those decades as well—most notably the 1984 ads announcing the new Macintosh, the "Think different" campaign, which started in 1997, and the wonderfully minimalist print ads for the iMac G3, which first appeared in 1998.

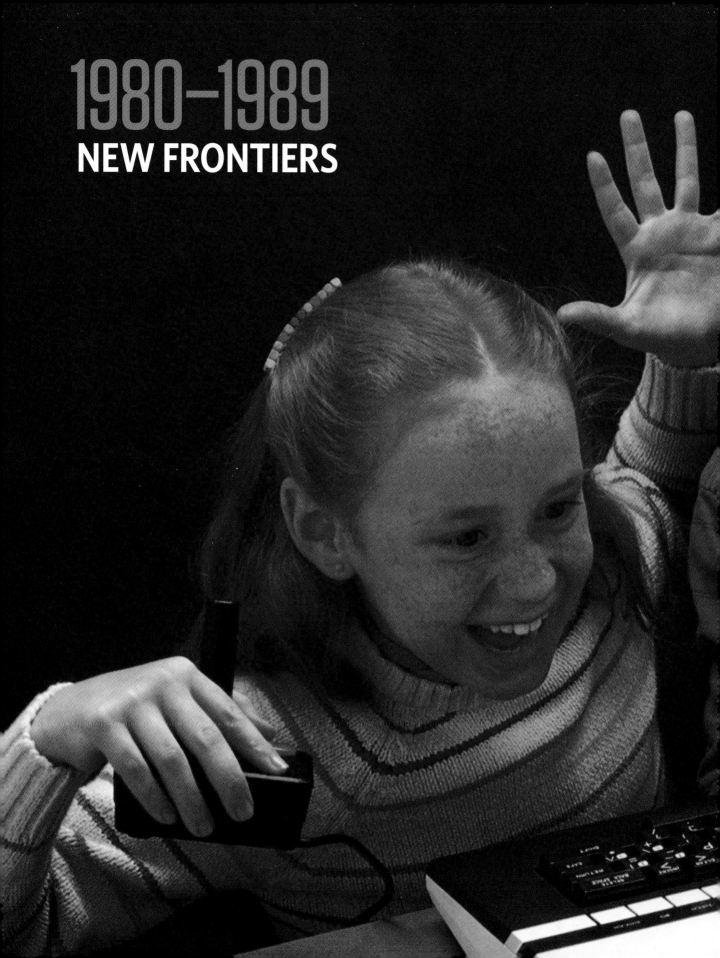

1980–1989
NEW FRONTIERS

1980

Hewlett-Packard releases its HP-85 — small, easy-to-use, and extremely versatile.

1980

Commodore's VIC-20 is backed by William Shatner, sold below $300, and available at toy stores.

1981

Sony begins selling its 3 ½-inch floppy disc drive, soon to become an industry standard.

1981

Resembling a snug briefcase, the Osborne 1 is geared towards the businessperson on-the-go.

1982

Commodore unveils the C64. An instant classic, it would go on to sell over 10 million units.

1982

"Pac-Man Fever" reaches #9 on the Billboard Hot 100 chart. "Do the Donkey Kong" just misses.

1982

Epson's HX-20 hits stores. Small and portable, it is routinely noted as the world's first laptop.

1982

Compact discs are introduced, bringing about a new era in data transfer and storage.

1983

In *WarGames*, a fun-loving teen unwittingly hacks the military's central computer system, WOPR.

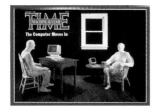

1983

On the January cover, *TIME* magazine's "Person of the Year" for 1982 is a personal computer.

1984

Apple's eagerly anticipated new computer, the Macintosh, makes a huge splash in the media.

1984

The term "cyberspace" enters the lexicon through William Gibson's novel *Neuromancer*.

1985

Japan-based Nintendo releases a home video game console for the American market called NES.

1985

Steve Jobs defects from Apple to form NeXT, which would focus on computers for education.

1985

The remote-controlled Omnibot 2000 is a must-have item for kids upon its release.

1985

Commodore enlists the help of Andy Warhol and Debbie Harry to launch the Amiga 1000.

1985

AOL originates as an "online bulletin board" specifically for Commodore computer-users.

1987

Recovering from the "video game crash of 1983," Atari releases the XEGS home console.

1987

Striking back against copycats, IBM releases the PS/2 featuring proprietary technology.

1988

Pixar's *Tin Toy* wins an Oscar, validating computer-generated storytelling as a viable artform.

1988

The Morris Worm gives many Internet-users their first bitter taste of a computer virus.

1989

World-renowned chess genius David Levy loses to a computer program named Deep Thought.

1989

Building on the success of its NES, Nintendo releases a new handheld console called Game Boy.

1989

Technology and counterculture collide in a new glossy magazine dubbed *Mondo 2000*.

The CRAY X-MP
Series of Computer Systems

CRAY

Atari, 1983 *(pages 158–159)*

Cray, 1985 *(opposite and right)*

Although the Cray-1, first unveiled in 1976, felt like a throwback to the mainframe systems of the 1950s and '60s, its technology was cutting edge, giving it the title of "the fastest computer in the world" for the next several years. Its visionary creator, Seymour Cray, who humbly referred to himself as "an overpaid plumber," came to be known as "the father of supercomputing" through a series of high performance machines in the 1970s and '80s.

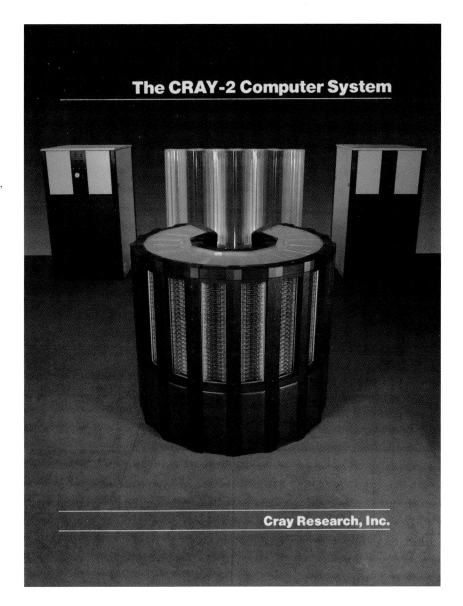

The CRAY-2 Computer System

Cray Research, Inc.

Motorola, 1983 *(left)*

NEC, 1981 *(opposite)*

NEC Microcomputers, Inc.
NEC

SPECTRAVIDEO™

SV·318
PERSONAL COMPUTER

"THE MOST BANG FOR THE BUCK"
—CREATIVE COMPUTING MAGAZINE*

COMPARISON CHART	SV 318	ATARI 800	COMMODORE 64
PRICE**	$299	$679	$595
INTELLIGENCE: ROM (READ ONLY MEMORY) BUILT-IN	32K	10K	20K
EXTENDED MICROSOFT™ BASIC BUILT-IN	YES	NO	NO
CP/M® COMPATIBILITY BUILT-IN	YES	NO	NO
MEMORY: RAM (RANDOM ACCESS MEMORY) BUILT-IN	32K	48K	64K
EXPANDABLE TO:	256K	NO	NO

*Manufacturers Suggested List Price as of April 1, 1983. CP/M is a registered trademark of Digital Research. Microsoft is a registered trademark of Microsoft Corp. Coleco is a trademark of Coleco Industries.

At the winter National Consumer Electronics Show, Creative Computing Magazine evaluated personal computers at practically every price level. Among them all there was one computer they reviewed as "astonishing." The new Spectravideo SV-318. The personal computer that can meet the needs of everyone in your family. It outthinks, outperforms, outplays its competition....for under $300. Compared to Atari 800 or Commodore 64, the SV-318 has more built-in intelligence (ROM) to let you do more. Built-in super extended Microsoft™ Basic language, the industry standard, makes it truly programmable. Built-in CP/M compatibility means access to over 3,000 of the most used business software programs. A built-in cursor control joystick makes editing easy and plays great arcade quality video games. (An optional adapter can plug you into the fabulous world of Coleco™ games). Spectravideo also delivers a low-priced and complete line of peripheral accessories today. Unlike some of our competitors, whose peripherals are always "coming soon." It takes an outstanding computer to outclass our competition. At under $300, nothing else even comes close. Today, discover the Spectravideo SV-318.

*April 1983

OUTTHINKS, OUTPERFORMS, OUTPLAYS ITS COMPETITION.

Spectravideo, 1980 *(opposite)*

Hewlett-Packard, 1985 *(right)*

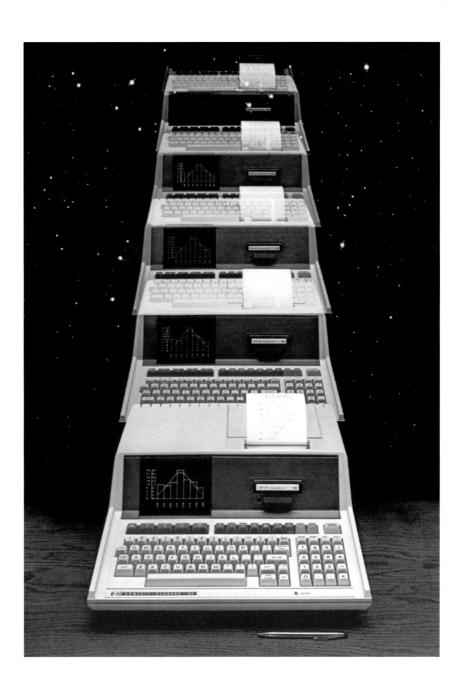

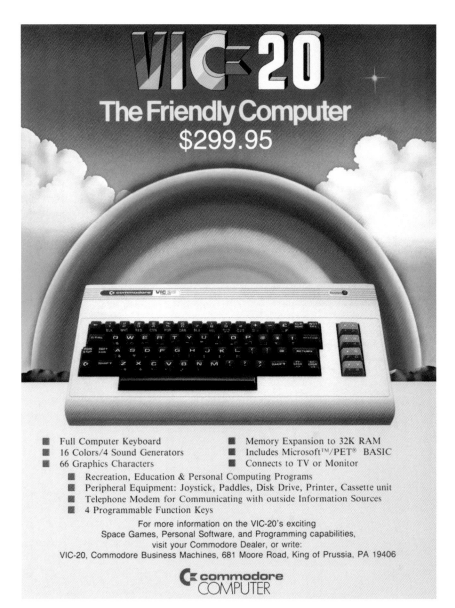

Commodore, 1982 *(left)*

Motorola, 1981 *(opposite)*

SPERRY UNIVAC
Series 1100
Vector Processing System

SPERRY⊕UNIVAC

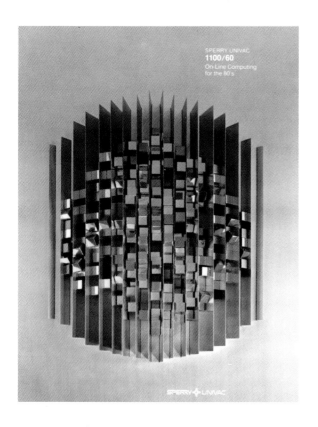

Sperry, 1982 *(opposite)*

Sperry, 1981 *(above left and right)*

Tandy, 1986 *(left)*

Tandy, 1981 *(opposite)*

Radio Shack Made the TRS-80® Color Computer Even Better!

At $399*, it's no wonder the 4K TRS-80 Color Computer is ideal for beginners. Now there's a TRS-80 Color Computer designed for more advanced applications, too.

TRS-80 Extended Color BASIC Computer. This high-performance computer includes a 16K ROM Extended BASIC with advanced graphics, eight brilliant colors, and sound for an unprecedented low price! You can draw fine lines, circles, rectangles, boxes and more with *easy-to-use one-line commands*. Four graphic modes with two color sets allow up to 49,152 programmable screen points (pixels). There's 225 separate tones for music or sound effects, too. All this on a 16K RAM machine (including video memory) loaded with the dynamic features a serious programmer demands. You get a 32-cpl x 16-line screen, multi-character variable names (two significant), editing, tracing, user-definable keys, 255-character string arrays, floating point 9-digit accuracy, and even machine language routines.

Priced at Only $599, the TRS-80 Extended Color BASIC Computer is useful, entertaining and educational. Yet using it can be as simple as plugging in one of Radio Shack's instant-loading Program Paks. The computer attaches to your TV, or our own $399 TRS-80 Color Video Receiver. For just $24.95, you can add a pair of joysticks which add flexibility to games and video displays. A built-in serial interface lets you attach a printer or a modem. A pair of tutorial, Extended Color BASIC instruction manuals are included, as well.

More Good News. Extended Color BASIC is also available as an upgrade kit ($99) for your 4K Color Computer (16K RAM required — $119). There's a modest installation charge for each kit.

New TRS-80 VIDEOTEX Software (with the modem shown below) offers quick, affordable access to various information and data services. The CompuServe® Information Service gets you local, national and international news, weather and sports from major newspapers, like The New York Times and The Washington Post, plus the Associated Press News Service; info on stocks and bonds; educational reference service; nationwide Electronic Mail and much more! The Dow Jones® Information Services provides stock exchange quotes—as recent as 15 minutes — plus feature selections from The Wall Street Journal and Barron's.

Only $29.95 Buys You VIDEOTEX Software including a free hour on both CompuServe and Dow Jones. Come see the new TRS-80 Color Computer, its programs and accessories, at your nearby Radio Shack today!

Radio Shack
The biggest name in little computers™
A DIVISION OF TANDY CORPORATION
6100 STORES AND DEALERS, 140 COMPUTER CENTERS AND 135 SERVICE CENTERS NATIONWIDE

NEW

A Low-Cost, Direct-Connect Modem. A convenient alternative to an acoustic coupler. The TRS-80 Modem I lets you enter the world of microcomputer communication for only $149. Cable extra.

Specifications: Low-Power CMOS Circuitry. Full duplex 300 baud. 103 compatible ANS/ORIG. Sensitivity: — 48 dBi — 43 dB. Connectors: DB25/4-pin DIN. Includes interface for Model I cassette port. FCC approved.

*Retail prices may vary at individual stores and dealers.
® CompuServe is a trademark of CompuServe, Inc.
® Dow Jones is a trademark of Dow Jones & Co., Inc.

Megasoft, 1985 *(opposite)*

Feedback, 1982 *(right)*

Feedback's line of robotics, with names like Armadillo, Armover, and Armsort, looked less like the Maschinenmensch from *Metropolis* and more like rugged industrial machinery, but their main purpose was educational so there was less emphasis on aesthetic value. "An unbeatable classroom motivator," Feedback promised its robots would "induce total student involvement like no other."

The Texas Instruments Home Computer.
If you think it's like having a tutor, an accountant, a librarian, a file clerk, and a pro football team at your fingertips, you're just starting to get the picture.

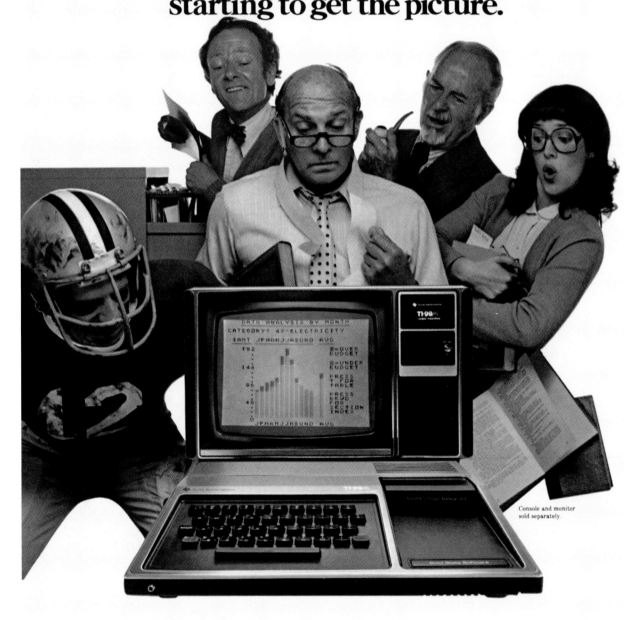

Console and monitor sold separately.

If you thought that beauty was only skin deep, you haven't seen the Olivetti M20. It combines both brains and beauty and, in fact, dollar for dollar the M20 is the most powerful personal computer on the market.

The M20 personal computer incorporates the latest technological advances. A true 16-bit processor. High resolution graphics, monochrome or color. A display that can be divided into 16 different windows. A memory capacity expandable up to 512 Kbytes and external disk storage of up to 11 MB. It also has outstanding communication

capabilities and its ergonomic design makes it a pleasure to work with.

It's not only supported by its own powerful operating system PCOS, but also by CP/M 80®, CP/M 86® and MSDOS®. Its program languages include Microsoft BASIC®, CBASIC, and Assembler. The M20 also has an extensive application library including electronic work sheets, word processing, data base management, scientific, technical and accounting programs.

The M20 is simple to use and keeps you up to date with the information you need – when you need it.

BRAINS & BEAUTY

olivetti

Xerox 860 Information Processing System

XEROX

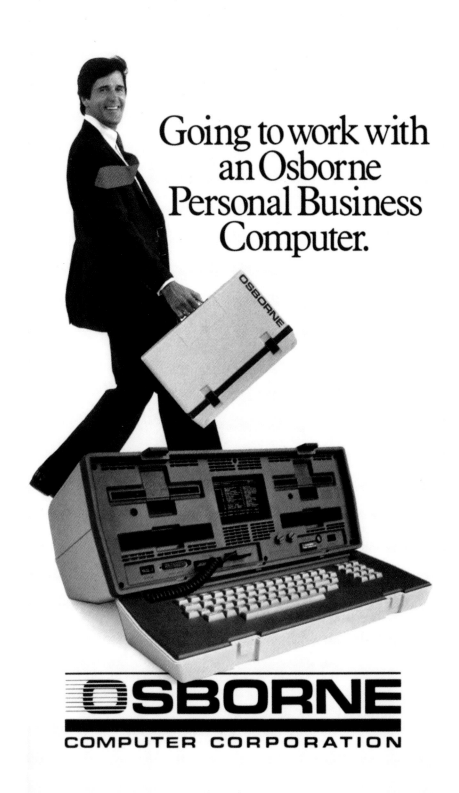

Going to work with an Osborne Personal Business Computer.

OSBORNE
COMPUTER CORPORATION

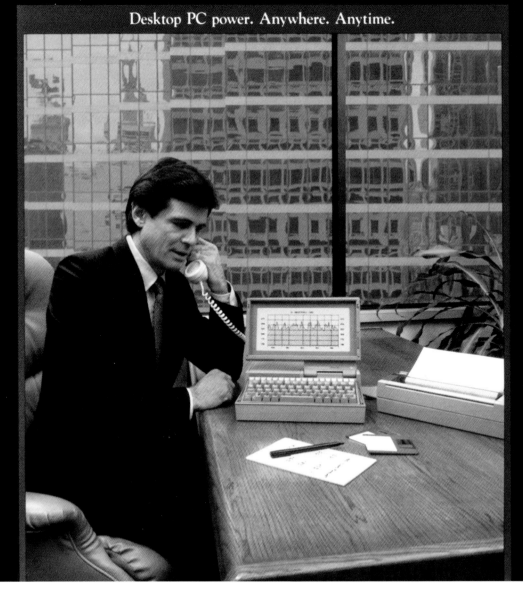

TEXAS INSTRUMENTS PRO-LITE™ COMPUTER

Desktop PC power. Anywhere. Anytime.

Texas Instruments, 1985
(opposite)

Sharp, 1984 *(right)*

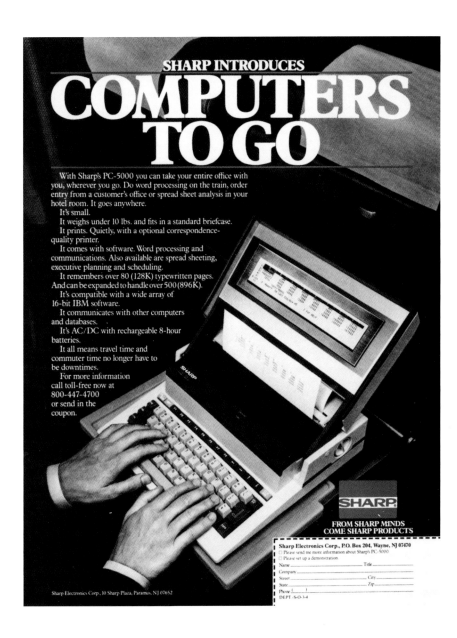

SHARP INTRODUCES

COMPUTERS TO GO

With Sharp's PC-5000 you can take your entire office with you, wherever you go. Do word processing on the train, order entry from a customer's office or spread sheet analysis in your hotel room. It goes anywhere.

It's small.

It weighs under 10 lbs. and fits in a standard briefcase.

It prints. Quietly, with a optional correspondence-quality printer.

It comes with software. Word processing and communications. Also available are spread sheeting, executive planning and scheduling.

It remembers over 80 (128K) typewritten pages. And can be expanded to handle over 500 (896K).

It's compatible with a wide array of 16-bit IBM software.

It communicates with other computers and databases.

It's AC/DC with rechargeable 8-hour batteries.

It all means travel time and commuter time no longer have to be downtimes.

For more information call toll-free now at 800-447-4700 or send in the coupon.

SHARP.

FROM SHARP MINDS COME SHARP PRODUCTS

Sharp Electronics Corp., 10 Sharp Plaza, Paramus, NJ 07652

Sharp Electronics Corp., P.O. Box 204, Wayne, NJ 07470
☐ Please send me more information about Sharp's PC-5000
☐ Please set up a demonstration
Name_____ Title_____
Company_____
Street_____ City_____
State_____ Zip_____
Phone (____)_____
DEPT -S-O-3-4

Arctec Systems, 1985 *(left)*

Amherst, 1982 *(opposite)*

THE RIGHT COMPANY CAN HAVE AMHERST ON A SILVER PLATTER

Industrial production technology is reaching out for new bases of growth — and it's taking hold in Amherst.

If your firm is engaged in robotics or machine tool and equipment manufacturing, Amherst is all yours.

AMHERST: THE PEOPLE

A solid base of technically-trained talent, schooled and skilled in electrical, mechanical and industrial engineering — the disciplines your industry demands with the productivity it deserves.

AMHERST: THE LOCATION

Within 500 miles of 60 percent of all North American manufacturing activity. Within 20 miles of some of the cheapest and most readily available hydro power in the country. Within a mile of one of America's foremost educational/research institutions.

IF YOU KNOW THAT ROBOTICS IS NOT A NEW VIDEO GAME, YOUR COMPANY COULD BE THE ONE.

AMHERST NEW YORK

And within minutes of all Western New York air, rail and superhighway access.

AMHERST: THE EXPERTISE

A team of experienced individuals, eager to cut through red tape to secure the package of tax incentives and financing vehicles required to get your company off the ground — quickly.

AMHERST: THE OPPORTUNITY

Qualified people. Strategic locale. Business know-how. It's all here for the right company — on a silver platter. Opportunity awaits you in Amherst.

FOR MORE INFORMATION, call or write JAMES J. ALLEN, *Executive Director, Amherst Industrial Development Agency, 5678 Main Street, Amherst, New York 14221. (716) 634-8575.*

Better yet, plan to visit us. We'll have your engraved silver platter waiting for you when you arrive!

CIRCLE 2

BASIC TUTOR

Let your Apple teach you to program in BASIC!

BASIC TUTOR makes learning BASIC easy. With it your Apple will give you step-by-step instruction in handling all the fundamental elements of the BASIC language.

BASIC TUTOR begins in lesson one by assuming you have no knowledge of programming. By the end of the last lesson you will be writing carefully planned, well-constructed programs of your own.

BASIC TUTOR is interactive, prompting you with questions to which you will respond at the keyboard. Positive reinforcement is given with each correct answer, and specific aid is provided with each incorrect answer to help lead you in the right direction. Also, frequent summaries and reviews help make your new knowledge stick.

BASIC TUTOR was designed for self-instruction. You can work at your own pace to optimize your learning curve. And **BASIC TUTOR** is fully compatible with Applesoft BASIC, so that any original programs you write will immediately run on your Apple computer.

BASIC TUTOR was written for SuperSoft by Courseware Applications, one of the pioneers in Computer Aided Instruction. Courseware Applications has had extensive experience in all areas of C.A.I., including corporate training programs, educational instruction (including programs for the international PLATO network), and military simulation courses. This experience has helped make **BASIC TUTOR** Computer Aided Instruction at its best.

With **BASIC TUTOR** you can turn your Apple into the greatest teacher you've ever had. So start learning BASIC today – with **BASIC TUTOR**.

Requires: Apple II DOS 3.3, 48K, one disk drive
BASIC TUTOR: $99.00

Apple II is a trademark of Apple Computers Inc.

FIRST IN SOFTWARE TECHNOLOGY P.O. Box 1628 Champaign, IL 61820 (217) 359-2112 Telex 270365

Supersoft, 1983 *(opposite)*

Okidata, 1983 *(right)*

GREAT NEWS FOR EVERYONE WITH A PERSONAL COMPUTER: A NEW BREED OF PRINTER, PURRRFECTLY PRICED.

High Performance Word and Data Processing For Under $700.

When advertising, TV and film people need a puma to pose or a lion on location, they call the Dawn Animal Agency. Daily, Dawn sends their exotic animals from coast to coast. And they generate a jungle of data in the process. Like so many growing businesses, they need to mate a personal computer to a printer that will keep pace with business demands. But won't take a huge bite from the budget.

Okidata's new multifunction Microline (ML) 92 printer is just the animal. For letters, memos or manuscripts, this advanced dot matrix printer gives you text printing that's a match for any daisywheel's. It prints graphs, charts and illustrations. Even emphasized and enhanced printing to help you stress a point. As for data processing, this cat doesn't pussyfoot around. Information flies from the 92 at 160 cps. And there's an ML 93, too, that adds wide-column printing to the picture.

Like each in our full line of high performance printers, the new ML 92 and 93 are built strong to keep on run-ning, right down to the print head that's guaranteed for one full year. But the really great news about each is price: $699 suggested retail for the ML 92; slightly more for its wide-column partner. Absolutely purrrfect.

For more detailed information, and for the name of the dealer nearest you, call 1-800-OKIDATA. In NJ, 609-235-2600.

OKIDATA
Mt. Laurel, NJ 08054
A subsidiary of Oki Electric Industry Company Ltd

All Okidata printers are compatible with Apple, IBM, Radio Shack, Osborne and just about every other personal computer.

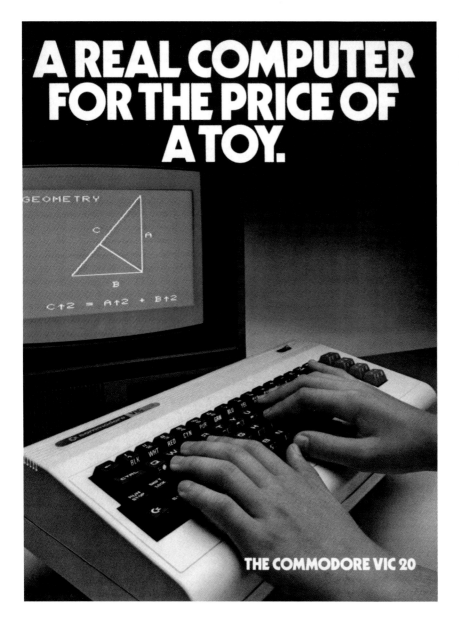

A REAL COMPUTER FOR THE PRICE OF A TOY.

THE COMMODORE VIC 20

Commodore, 1982 *(left)*

At the height of the VIC-20's popularity in 1982, Commodore was producing 9,000 units per day. Priced under $300 and sold at a variety of retailers (not just electronics stores) it was meant to compete with other general purpose computers such as the Apple II and Atari 800. With the help of a TV spot by William Shatner in which he calls it "the wonder computer of the 1980s" the VIC-20 would become one of the first computers to sell over one million units.

Tandy, 1982 *(opposite)*

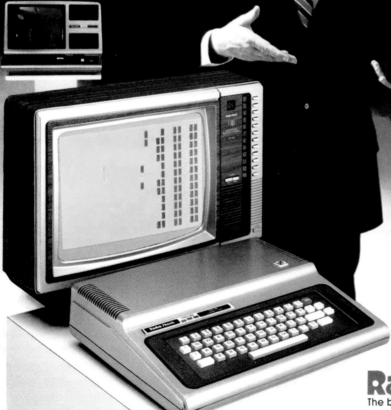

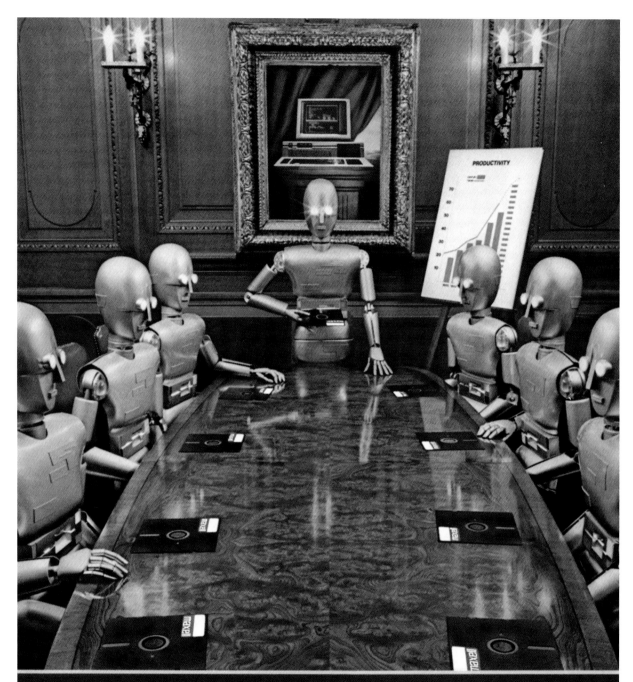

When computers get down to business, they move up to Maxell.

Maxell is ready when you are with the newest technology in magnetic media. A perfect example is this double-sided 3½" microdisk.

Maxell, 1986 *(opposite)*

Atari, 1981 *(right)*

Aerospace was an early driver of computer technology so it makes sense that Gordon Cooper was hired as a spokesperson for Atari. Known as a video game company up to that point, the 800 was an attempt to cash in on some of the success being enjoyed by Apple and Commodore for their entries into the personal computer market by appealing to an older generation who regarded the Project Mercury astronaut as a hero.

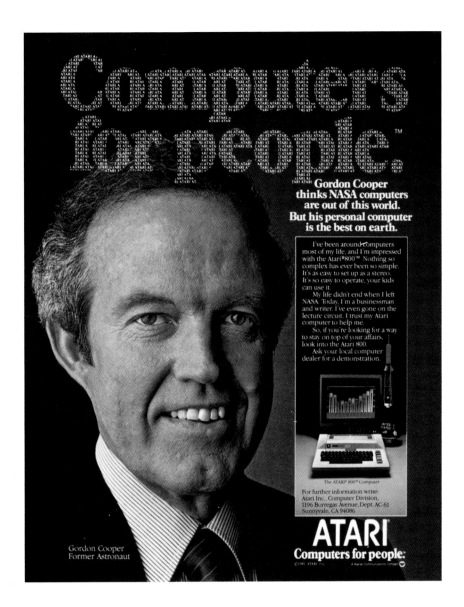

Computers for people.™

Gordon Cooper thinks NASA computers are out of this world. But his personal computer is the best on earth.

I've been around computers most of my life, and I'm impressed with the Atari® 800™ Nothing so complex has ever been so simple. It's as easy to set up as a stereo. It's so easy to operate, your kids can use it.

My life didn't end when I left NASA. Today, I'm a businessman and writer. I've even gone on the lecture circuit. I trust my Atari computer to help me.

So, if you're looking for a way to stay on top of your affairs, look into the Atari 800.

Ask your local computer dealer for a demonstration.

The ATARI® 800™ Computer

For further information write: Atari Inc., Computer Division, 1196 Borregas Avenue, Dept. AC-61 Sunnyvale, CA 94086.

ATARI

Computers for people:

Gordon Cooper
Former Astronaut

COMMODORE COMPATIBLE SINGLE DISK DRIVE

Commodore™ owners, are you ready for a disk drive that delivers more FEATURES, PERFORMANCE AND COMPATIBILITY at a competitive price to the 1541? Peripheral Systems of America CS-1™ gives you all that the existing drives offer and much more.

FEATURES:
- 100% compatible.
- Reset button to save wear and tear on your disk drive.
- Free utility software - Q-Load (fast load), Copy-Q (fast copy).
- External switch for selecting device number.
- Data error detection and correction feature.
- Reliable @ Save function.
- Formats in 16 seconds.
- State of the art design - streamlined with an external power supply.
- Reliable and durable.
- 90 day limited warranty.
- 9 month extended warranty available.

C-64 is a registered trademark of Commodore Business Machines Inc.
DEALER INQUIRIES WELCOME

Other products offered by Peripheral Systems of America:

FOR COMMODORE
Hardware: Dual Drive, Serial Interface, 300 Baud Modem, Graphic Printer Interface, Fast Load/DOS Cartridge, Light Pens, Joysticks.
Software: Terminal Program, Back-Up Copy, Five Modular Accounting Packages

OTHER COMPUTERS
4-Color Centronics Plotter/Printer, Disk Notcher

PSA
Peripheral Systems of America, Inc.

PRODUCTS YOU CAN BELIEVE IN

Peripheral Systems of America, 1985 *(left)*

Blue Sky Software, 1984 *(opposite)*

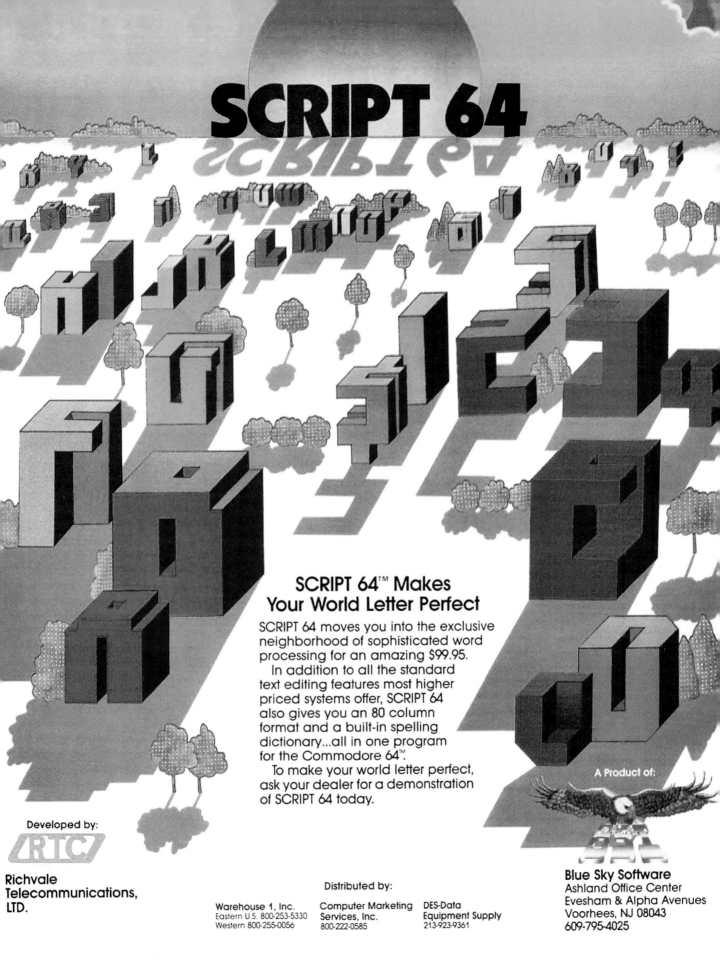

SCRIPT 64

SCRIPT 64™ Makes Your World Letter Perfect

SCRIPT 64 moves you into the exclusive neighborhood of sophisticated word processing for an amazing $99.95.

In addition to all the standard text editing features most higher priced systems offer, SCRIPT 64 also gives you an 80 column format and a built-in spelling dictionary...all in one program for the Commodore 64™.

To make your world letter perfect, ask your dealer for a demonstration of SCRIPT 64 today.

A Product of:

Developed by:

Richvale
Telecommunications,
LTD.

Distributed by:

Warehouse 1, Inc.
Eastern U.S. 800-253-5330
Western 800-255-0056

Computer Marketing
Services, Inc.
800-222-0585

DES-Data
Equipment Supply
213-923-9361

Blue Sky Software
Ashland Office Center
Evesham & Alpha Avenues
Voorhees, NJ 08043
609-795-4025

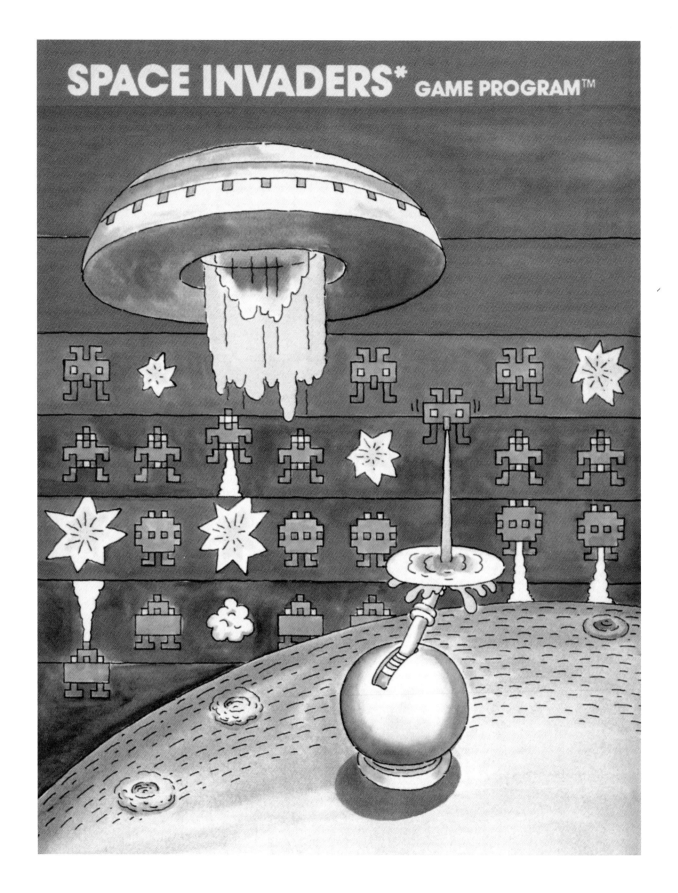

TO BEAT OUR NEW HOME VIDEO GAME, YOU'VE GOT TO MOVE YOUR BUNS.

If you've been waiting for the home version of one of America's hottest arcade games, your order is ready. Introducing BurgerTime™* from Mattel Electronics. For your Intellivision,® Atari® 2600, Apple® II,** Aquarius™**or IBM® Personal Computer.

Your job is to climb up the ladders and assemble an order of giant hamburgers. But you've got to do it fast because you're being chased by killer hot dogs, sour pickles and a very nasty fried egg.

Good thing you've got your pepper shaker. One shake and they're stunned.

Shown on Intellivision. Game varies by system.

But just make sure you don't run out of pepper. Because you know what happens then.

You stop making lunch. And you start becoming it.

FROM MATTEL ELECTRONICS®

* Trademark of Data East USA, Inc. used under license. © 1982 Data East USA, Inc.

**Coming soon. © Mattel Electronics, Inc. 1983. All Rights Reserved.

NBA* Basketball

NASL* Soccer

Utopia™

Auto Racing

PBA* Bowling

Checkers

PGA* Golf

Reversi™

The Electric Company™** Math Fun™

Boxing

ABPA* Backgammon

The Electric Company™** Word Fun™

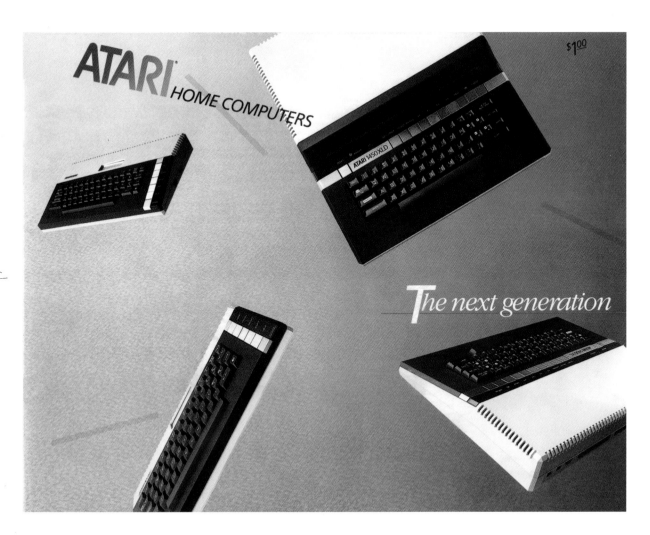

Mattel, 1983 *(opposite)*

Atari, 1983 *(above)*

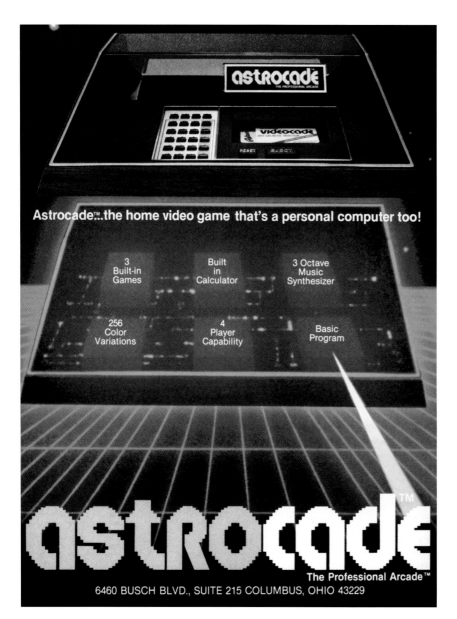

Bally, 1982 *(left)*

Atari, 1982 *(opposite)*

Dig Dug™.
Totally awesome.

Dig a maze down deep in the ground.
When a flower sprouts you play
 another round.
Use your pump just like a bazooka.
Use it to puff up the bad, bad Pooka™
Pump up Fygar™, put out his flame.
Eat all the Veggies and win the game.
 There's a lot more. But you've got
to play it to get *all* the action. It's DIG
DUG, the new ATARI* *coin* video
game that's shaking the whole coun-
try. It's excellent!

Humor, suspense, different skill lev-
els, challenge to the max DIG
DUG has it all! Dig it. Play it. Ask for
it where you play coin video games.
 There's still more. Get into our free
drawing for a home ATARI Video
Computer System™ Write your name
and address on a card and send it,
postmarked no later than August 31,
1982, to: DIG DUG Drawing, Atari, Inc.,
Coin Games Division, 790 Sycamore
Dr., P.O. Box 906, Milpitas, CA 95035.

ATARI®

When the IRS needed an office on the road, Zenith withheld nothing.

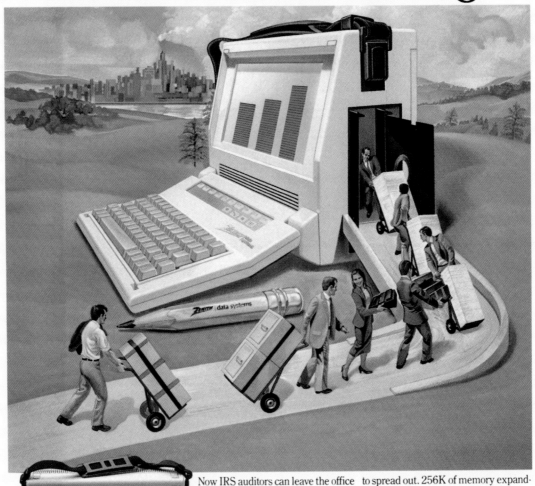

Now IRS auditors can leave the office with just about everything but the coffee pot tucked under one arm.

Thanks to Zenith's amazing Z-171 Portable PC.

PC COMPATIBLE

With dual 5¼″ floppy disk drives and compatibility with most IBM software, the Z-171 gives auditors in the field access to pertinent home-based files.

But that's only the beginning. The Z-171 gives the IRS a full-size, backlit LCD screen, with plenty of room for spreadsheets

to spread out. 256K of memory expandable to 640K. An optional built-in modem and rechargeable battery pack, and much more. All folding neatly into a package under 15 pounds.

Find out why the Z-171 came out on top in one of the most thorough audits ever made.

For more information, and the name of your nearest Zenith Data Systems dealer, call **1·800·842·9000, Ext. 1.**

ZENITH | data systems

Zenith, 1986 *(opposite)*

Motorola, 1980 *(right)*

Microcomputer Development Systems

Continuing Education in Computers

Ask About Radio Shack's Training Sessions for Teachers

Operating a microcomputer isn't like operating a movie projector or tape recorder. That's why Radio Shack's offer to train teachers and administrators is such a great opportunity. You can learn elementary and advanced programming, as well as get "hands-on" experience with the TRS-80 computer—all at no charge. Expert instructors at any of our more than 400 Computer Centers conduct these sessions and explain about computers in plain English, not "computerese". Best of all, these training sessions can be arranged to fit your schedule—just contact your nearest Radio Shack Computer Center or call your Regional Educational Coordinator. Ask to see our wide selection of TRS-80 computer courseware, too.

For the Name of Your Regional Educational Coordinator, Call Toll Free, 800-433-5682. In Texas, Call 800-772-8538.

For More Information About Radio Shack
Educational Products and Services, Mail to:
Radio Shack, Dept. 84-A-029
300 One Tandy Center, Fort Worth, Texas 76102

NAME _____
SCHOOL _____
ADDRESS _____
CITY _____ STATE _____ ZIP _____

Radio Shack®
The biggest name in little computers®
A DIVISION OF TANDY CORPORATION

Tandy, 1984 *(left)*

Along with the Commodore PET and Apple II, Tandy's TRS-80 was one of the first mass-produced personal computers. Collectively known as the "1977 Trinity," they helped fill the gap between hobbyists and the average consumer. Though it came fully assembled, there was a steep learning curve, so Radio Shack began offering training services for its rapidly expanding clientele.

McGraw-Hill, 1980 *(opposite)*

By 1980, the personal computer revolution was in full swing, and trade magazines such as *Byte* and *onComputing* materialized to meet the new demand. They spoke mostly to the uninitiated—those whose knowledge of computers may have been gleaned through pop culture channels such as TV (*Star Trek*) or movies (*2001: A Space Odyssey*) but weren't yet privvy to the ways in which an Apple II or Commodore PET could benefit their lives.

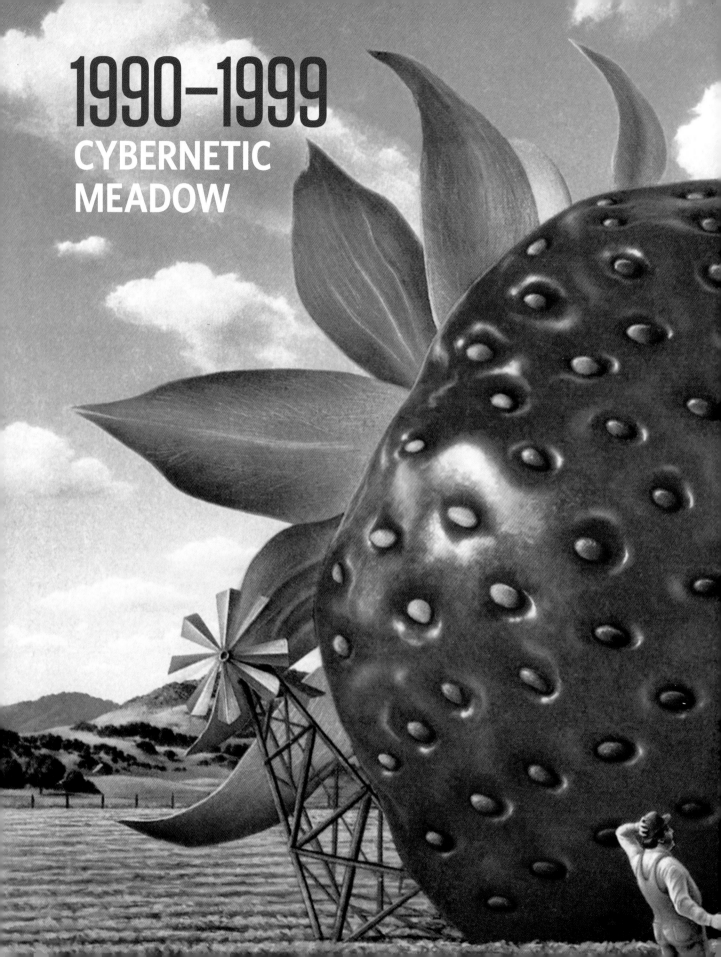

1990–1999
CYBERNETIC
MEADOW

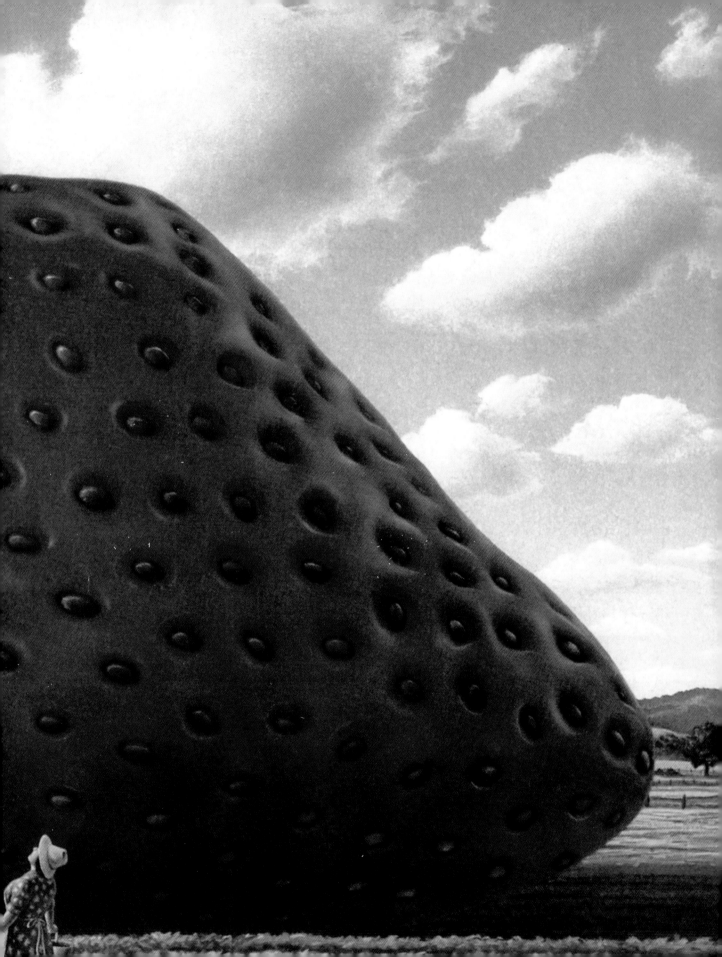

1990

The Secret Service cracks down on unlawful hacking activities in Operation Sundevil.

1991

Brit scientist Tim Berners-Lee unveils the World Wide Web to the general public.

1992

IBM releases its ThinkPad line of notebook computers named after company slogan, "THINK."

1992

Joint Photographic Expert Group formulates JPEG to keep file sizes down without loss of quality.

1993

A homicidal, first-person shooter game called *Doom* is released and becomes wildly successful.

1993

Covering the culture of technology, the first issue of *Wired* magazine hits newsstands.

1993

Mosaic becomes the preferred web browser for the burgeoning World Wide Web.

1993

Violent video games including *Mortal Kombat* are probed in a congressional hearing.

1994

The Zip Drive is introduced by Iomega with a maximum storage capacity of 100 megabytes.

1995

Sony Playstation utilizes CD-Rom technology to make games bigger and better than ever.

1995

Amazon goes online. Conducting business out of a garage, its first sale is a book.

1995

The DVD is "invented" when Sony and Toshiba manufacture discs under a single format.

1995

AuctionWeb, later re-named eBay, is founded. Its first sale is a busted laser pointer.

1995

A "browser war" kicks off with Netscape and Microsoft locking horns to establish dominance.

1996

PalmPilot proves there is a viable market for PDA (Personal Digital Assistant) devices.

1996

At Stanford, two students have a research project called BackRub, later renamed Google.

1997

Bill Gates pumps $150 million into Apple, thereby saving the company from ruin.

1998

Dave Hampton creates a "robotic pet" called Furby, which becomes a must-have item for kids.

1998

Nora Ephron's *You've Got Mail* portrays the unique possibilities of an online romance.

1998

iMac signals the end of a rough patch for Apple, and with Steve Jobs back, the future is bright.

1999

Digital Millennium Copyright Act is passed by the U.S. Congress to address Internet theft issues.

1999

Wireless Ethernet Compatibility Alliance initiates the widespread use of the term Wi-Fi.

1999

Online journals proliferate with the appearance of platforms such as Blogger and LiveJournal.

1999

The world prepares for the Y2K bug—a coding flaw, which would allegedly invoke doomsday.

LOVERS

FRIENDS

OTHERS

DATING. MATING. RELATING. ON THE WORLD WIDE WEB.

HTTP://WWW.SWOON.COM

Minolta, 1992 *(pages 202–203)*

Swoon.com, 1998 *(opposite)*

In 1965, a group of undergrads at Harvard developed one of the first fully computerized dating services, dubbed Operation Match. Singles would fill out a questionnaire and a mammoth IBM computer would analyze the data and determine the best partner for each person. By the late '90s, a handful of online dating websites had materialized including Match, JDate, and Swoon.

Sun Microsystems, 1998 *(right)*

With intonations of the original '50s hacker ethic that information should be free and accessible to all, Sun Microsystems used a direct typographic treatment to promote network computing by way of its Java platform. The phrase "The Network is the Computer" was coined by Sun founder John Gage to promote the company's line of servers, a concept which lives on today in the form of cloud computing.

INFORMATION SHALL CIRCULATE AS FREELY AS OFFICE GOSSIP.

"Pssst." Information can pass from person to person without a hiccup. So why not from computer to computer? Little wonder we've always spread the word about a more fluent approach to computing: Network computing. With our Java™ technologies, we're enabling the desktop to communicate with the palmtop to communicate with the pager to communicate with the TV. So everyone can share information better within the company and beyond. Talk amongst yourselves. THE NETWORK IS THE COMPUTER.™

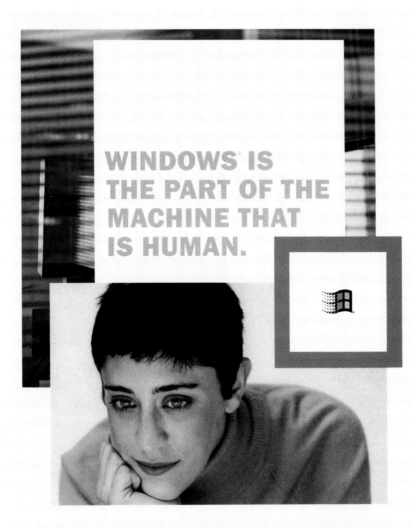

WINDOWS IS
THE PART OF THE
MACHINE THAT
IS HUMAN.

Where do you want to go today?® **www.microsoft.com**/windows/ **Microsoft**®

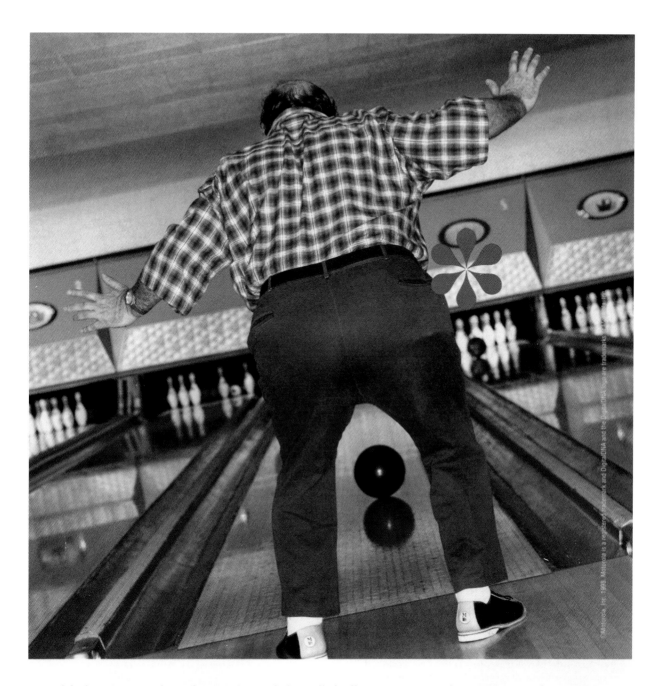

It's in your pocket: A smart card that digitally stores your insurance and medical information on a chip. Which would really come in handy, if say you pulled your back out, slipped, or dropped something on your toe.

IT'S HERE.

Wouldn't it be nice if your work was *impossible* to ignore?

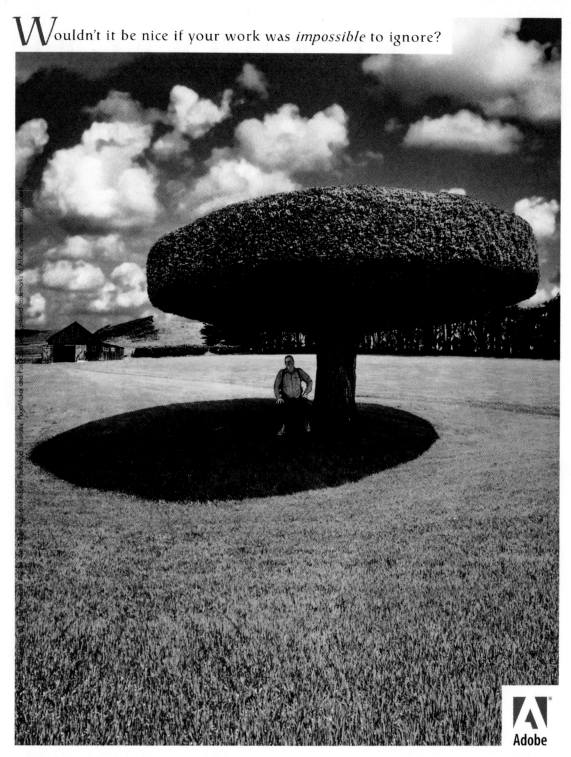

Adobe, 1998 *(opposite)*

Virtual i-O, 1996 *(right)*

There were two distinct versions of
the short-lived Virtual i-O i-glasses:
one for computer-based applications
and another for video games and TV.
Marketing material claimed it was
like having an 80-inch big screen
attached to your face, and at only
eight ounces was breezy enough to
bring into bed. The ad appealed to
the average Joe who watches sports,
and it foreshadowed the state of ever-
connectedness that would come with
the smartphone revolution in the
following decade.

**JUST BECAUSE SHE'S BUSY COUNTING
SHEEP DOESN'T MEAN YOU CAN'T BE
COUNTING TOUCHDOWNS.**

INTRODUCING VIRTUAL i-glasses!, THE WORLD'S FIRST AND ONLY PERSONAL BIG SCREEN DESIGNED WITH BOTH OF YOU IN MIND. YOU GET TOUCH-DOWNS (COMPLETE WITH THE SIX-POINT FROLIC) THE WAY THEY WERE MEANT TO BE SEEN *AND HEARD* — ON A COLOSSAL, CRYSTAL-CLEAR, FULL-COLOR SCREEN WITH INTEGRATED SPATIALIZED STEREO SOUND. AND IF THE GAME'S A BLOWOUT · CHANNEL SURF UNTIL YOUR THUMB IS NUMB · SHE WON'T EVEN KNOW. YOU HAVEN'T SEEN ANYTHING LIKE THIS IN YOUR HOME BEFORE. VIRTUAL i-glasses! VTV ARE AFFORDABLE, TOO. THEY'RE SUBSTANTIALLY LESS THAN YOUR ORDINARY BIG-SCREEN TV. YET THEY ARE ANYTHING BUT ORDINARY. AND DID WE MENTION THEY CAN HOOK UP TO YOUR VCR, LASERDISC PLAYER, AND VIDEO GAME SYSTEM? WELL, THEY CAN. **VIRTUAL i-glasses! VTV MODEL STARTING AT $399.**

i·glasses!

YOU HAVEN'T SEEN THIS BEFORE™

FOR MORE INFORMATION CALL 1-800-646-3759 OR VISIT http://www.vio.com OR RUSH OUT TO *the good guys!* OR **WIZ** AND SCORE YOURSELF A PAIR.

Has work become a pencil-pushing, torture-filled, stress-fest? Why not escape into a vacation of colors with new Game Boy® Color? Play old and new Game Boy® games in incredible color and make your gray flannel day go away.

New Game Boy® Color. Escape to Color.

Nintendo, 1998 *(left)*

Upon its initial release in 1998, the Game Boy Color was presented as a beacon of hope in an otherwise "pencil-pushing, torture-filled, stress-fest" world. The image of a drab middle-aged man slumped beneath his desk while clutching a purple console as if it were a brick of gold drove home the point. With almost 119 million units of the Game Boy line sold between 1989 and 2003, many seemed to agree.

Microsoft, 1998 *(opposite)*

Where do you want to go today?®

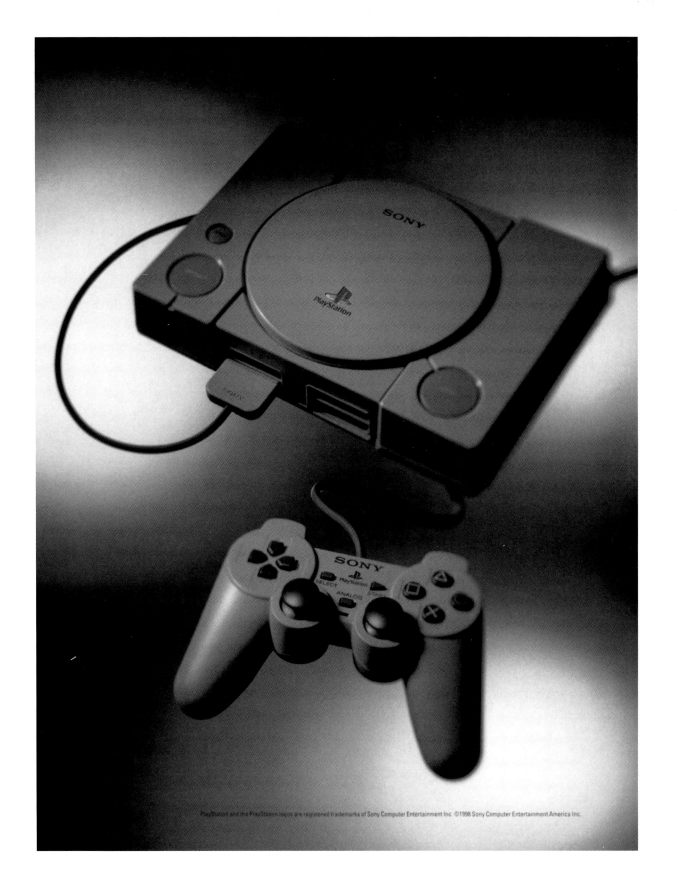

PlayStation and the PlayStation logos are registered trademarks of Sony Computer Entertainment Inc. ©1998 Sony Computer Entertainment America Inc.

Sony, 1998 *(opposite)*

Intel, 1998 *(right)*

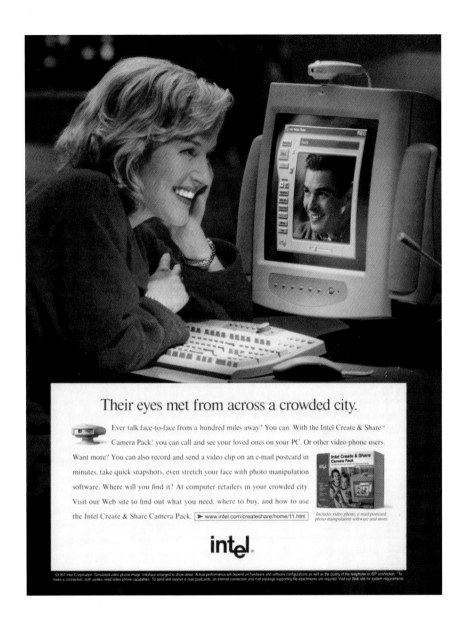

Adobe, 1998 *(left)*

Microsoft, 1998 *(opposite)*

Works better. Plays better.

98

WINDOWS® 98

THINKS

THE

INTERNET

SHOULD LOOSEN UP

LIVE

AND

A LITTLE.

Where do you want to go today?® **Microsoft**®

www.microsoft.com/windows98/internet/

Talking in the halls.

Incessant phone calls.

Co-workers swinging by.

Other people's "private" conversations.

The only thing wrong

with your cubicle is that you're

expected

to work

there.

Intel, 1997 *(opposite)*

Compaq, 1992 *(right)*

Introducing the Compaq Armada 1500.
Starting at $1,999,
it is the affordable notebook
that makes it easy for you
to work wherever
you need to go
to get your job done.
It comes with fully integrated features,
so you don't have to
lug around extra parts.
Up to 133MHz Pentium® processor,
10X CD-ROM,
up to 1.4GB hard drive,
floppy drive
(swappable with a 2nd battery),
33.6Kbps data/fax modem
and AC adapter, all built in.
To locate a Compaq Authorized Reseller,
call 1-800-943-7656 or
visit www.compaq.com.

COMPAQ

Has It Changed Your Life Yet?

simply
holds
everything.
travels
well.
one size
fits all.
home or
office.
the SENS™
Pro 500
notebook.
available
in slate
blue.
simply
samsung.

microprocessor
100/120/133/150
MHz Pentium®
processor.

screen
12.1" SVGA
active matrix or
11.3" SVGA dual
scan display.

hard drive
1.08/1.3/2.1 GB.

memory
8 to 40 (dual
scan) or 16 to
48 (active matrix)
MB EDO DRAM.

keyboard
ergonomic
palm rest.
SENS touch pad.

battery
NiMH/Lithium Ion.

audio
16-bit stereo
Sound Blaster®
compatible.
embedded duplex
speaker.

fax/modem
built-in 28.8Kbps
fax/modem.*

software
Windows® 95.

reliability
24-hour/7-day
live support.
3-year warranty.

1 800 933 4110
www.sosimple.com

Go from the dance floor
to the trading floor in your pajamas.

NETSCAPE®

From music to finance, to just about anything else.
Netscape® Netcenter™ is one place on the Internet where all your interests come together,
just the way you like them. Where you get all the tools you need to do all the things you want online.

Watching a hot stock? Put your portfolio front and center on your **customized** *My Netscape* page. From news to sports to weather, you'll always get what you want, when you want, the way you want it.

Of course, sometimes you'll want to head out into unexplored territory, so at Netcenter we've also got six different **search engines** to make sure you always find what you're looking for.

There's also our free **WebMail** e-mail service, so it's easy to connect with anyone, from Peoria to Phnom Penh. Basically, the world comes to you. And isn't that what the Internet is supposed to be all about?

netscape.com
The world according to you

The Microsoft Network. Now serving prime cuts of

on a big old *silverplatter.*

For a free one-month, unlimited trial,* call 1-800-FREE MSN.

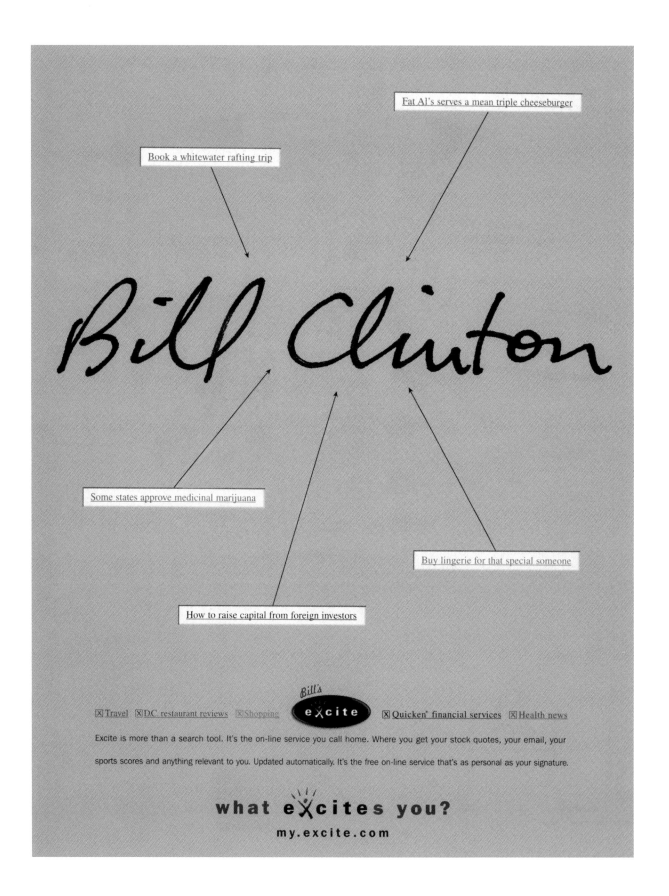

Microsoft, 1996 *(pages 222–223)*

Excite.com, 1998 *(opposite)*

Sony, 1998 *(right)*

It's a breakthrough any way you look at it.

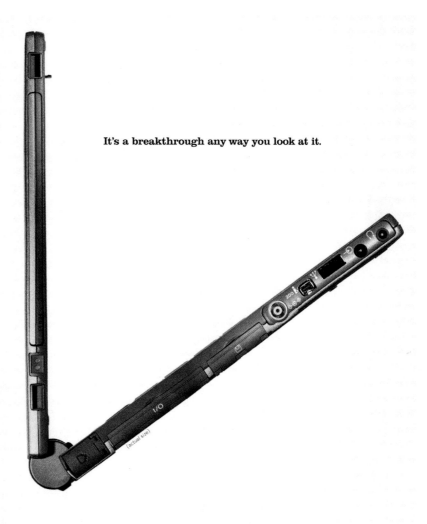

(actual size)

VAIO 505 SuperSlim Notebook

Introducing the Sony VAIO® 505 SuperSlim notebook computer. Buy yours now at participating Sony retailers, direct from Sony VAIO Direct™ at 1-877-SONY-NOW or on the web at www.sony.com/505

SONY

Windows 95 makes multimedia even more multi.

Microsoft
WHERE DO YOU WANT TO GO TODAY?™

DIGITAL'S PC PRODUCT LINES

HINOTE

VENTURIS

CELEBRIS

PRIORIS

MONITORS

Microsoft, 1995 *(above left)*

DEC, 1995 *(above right)*

IBM, 1996 *(opposite)*

Presenting the IBM PC Server 320 Internet Series Solution.
It doesn't get much easier than this.

Call 1 800 426-7255, ext. 4116. Or visit us at www.pc.ibm.com/servers/.

Solutions for a small planet™

APPENDICES

ENDNOTES—SELLING TECH

1 Kenneth Flamm, *Creating the Computer: Government, Industry, and High Technology*. (Washington, D.C.: Brookings Institution, 1988), 87–88.

2 An ad for the 1955 Oldsmobile "88" Holiday Coupe shows its "Rocket" engine hovering weightlessly inside of an atom.

3 The Big Idea was a trend in American advertising that had its heyday during the 1960s. Humor, irony, and wit were used in place of market research to create an emotional connection to the brand or product.

4 "New England Highway Upsets Old Way of Life," *Business Week*, May 14, 1955.

5 The traitorous eight included: Gordon Moore, Sheldon Roberts, Eugene Kleiner, Robert Noyce, Victor Grinich, Julius Blank, Jean Hoerni, and Jay Last.

6 The Creative Revolution was a movement that occurred in American advertising of the 1960s in which art directors and copywriters worked hand in hand to create innovative ad campaigns that pushed boundaries, broke conventions, and elevated advertising to the level of art.

7 Stewart Brand, "We Owe It All to the Hippies," *TIME*, March 1, 1995.

8 Steven Levy, *Hackers: Heroes of the Computer Revolution*. (Sebastopol, CA: O'Reilly Media, 2010), 27–34.

9 John Markoff, *What the Dormouse Said: How the Sixties Counterculture Shaped the Personal Computer Industry*. (New York: Penguin Books, 2006), xiv–xv.

10 Intel released its first microprocessor chip in 1971, and at Xerox's PARC (Palo Alto Research Center), an all-star team of engineers were building "the office of the future."

11 Roberto Dillon, *Ready: A Commodore 64 Retrospective*. (Singapore: Springer, 2015), 8–10.

12 Also known as the "Atari Shock," the video game crash of 1983 was an industry-wide recession stemming from an oversaturated marketplace.

13 Richard Brautigan, *All Watched Over by Machines of Loving Grace*. (San Francisco: Communication Company, 1967)

14 "Perry Chen by Gideon Jacobs," *BOMB*, accessed May 11, 2019, https://bombmagazine.org/articles/perry-chen/.

15 Danny Hillis, "Why Do We Buy the Myth of Y2K?" *Newsweek*, May 31, 1999, 12.

IBM campus, San Jose,
ca. 1958 *(pages 228–229)*
Photo by Arnold Del Carlo

IBM 1401, 1959 *(page 236)*
Photo by James Ball

HDR 75, ca. 1975 *(page 237)*
Photo by James Ball

Olivetti Elea 9003, 1959
(page 238) Photo by James Ball

ICL 7500, 1971 *(page 239)*
Photo by James Ball

Honeywell, 1966 *(page 240)*

BIBLIOGRAPHY

Brand, Stewart. "Spacewar: Fanatic Life and Symbolic Death Among the Computer Bums." *Rolling Stone*, December 7, 1972.

Bridle, James. *New Dark Age: Technology and the End of the Future*. London: Verso, 2018.

Burck, Gilbert. "'On Line' in 'Real Time.'" *Fortune*, April 1964.

Bush, Vannevar. "As We May Think." *The Atlantic*, July 1945.

Ceruzzi, Paul E. *A History of Modern Computing*. Cambridge, MA: MIT Press, 2003.

Chang, Emily. *Brotopia: Breaking up the Boys Club of Silicon Valley*. New York: Penguin, 2018.

Evans, Claire L. *Broad Band: The Untold Story of the Women Who Made the Internet*. New York: Portfolio/Penguin, 2018.

Fisher, Adam. *Valley of Genius: The Uncensored History of Silicon Valley, as Told by the Hackers, Founders, and Freaks Who Made It Boom*. New York: Grand Central Publishing, 2018.

Gertner, Jon. *The Idea Factory: Bell Labs and the Great Age of American Innovation*. New York: Penguin, 2013.

Gleick, James. *The Information: A History, a Theory, a Flood*. New York: Pantheon Books, 2011.

Hafner, Katie and Matthew Lyon. *Where Wizards Stay up Late: The Origins of the Internet*. New York: Simon & Schuster, 2006.

Harris, William "The Astonishing Computers." *Fortune*, June 1957.

Heimann, Jim and Steven Heller. *All-American Ads 60s*. Cologne: TASCHEN, 2002.

Heimann, Jim and Steven Heller. *All-American Ads 70s*. Cologne: TASCHEN, 2004.

Hiltzik, Michael A. *Dealers of Lightning: Xerox PARC and the Dawn of the Computer Age*. New York: HarperCollins, 2000.

Kidder, Tracy. *The Soul of a New Machine*. Boston: Little, Brown and Company, 1981.

Kries, Mateo, Christoph Thun-Hohenstein, and Amelie Klein. *Hello, Robot: Design between Human and Machine*. Weil am Rhein, Germany: Vitra Design Museum, 2017.

Lohr, Steve. *Digital Revolutionaries: The Men and Women Who Brought Computing to Life*. New York: Roaring Brook Press, 2009.

Malone, Michael S. *The Intel Trinity: How Noyce, Moore, and Grove Built the World's Most Important Company*. New York: HarperCollins, 2014.

Meggs, Philip B. *A History of Graphic Design*. New York: J. Wiley and Sons, 1998.

Nelson, Theodor H. *Computer Lib/Dream Machines*. Chicago: Theodor H. Nelson, 1974.

Nicholson, Matt. *When Computing Got Personal: A History of the Desktop Computer*. Bristol, England: Matt Publishing, 2014.

Pincas, Stephane, and Marc Loiseau. *A History of Advertising*. Cologne: TASCHEN, 2008.

Reid, T. R. *The Chip: How Two Americans Invented the Microchip and Launched a Revolution*. New York: Simon & Schuster, 1986.

Saxenian, AnnaLee. *Regional Advantage Culture and Competition in Silicon Valley and Route 128*. Cambridge, MA: Harvard University Press, 1996.

Smith, Douglas K., and Robert C. Alexander. *Fumbling the Future: How Xerox Invented, Then Ignored, the First Personal Computer*. New York: toExcel, 1999.

Turner, Fred. *From Counterculture to Cyberculture: Stewart Brand, the Whole Earth Network, and the Rise of Digital Utopianism*. Chicago: University of Chicago Press, 2008.

Ullman, Ellen. *Life in Code: A Personal History of Technology*. New York: Picador, 2018.

Waldrop, M. Mitchell. *The Dream Machine: J. C. R. Licklider and the Revolution That Made Computing Personal*. New York: Penguin, 2002

CREDITS

Every reasonable effort was made to identify and contact the individuals and companies associated with the images in this book. Any omissions of copy or credit are unintentional and will be amended in future editions if such copyright holders contact the publisher. All images not listed are part of the author's collection. Additional images provided courtesy of:

page 1: Courtesy of the Computer History Museum (CHM Image #: 102646132; Title: The UNIVAC 494 Real-Time System, Operation Big Time in Real-Time; Maker: Sperry Rand Corporation; Date: 1966) **page 2**: Courtesy of the Computer History Museum (CHM Image #: 102646153; Title: Nova, Super Nova; Maker: Data General Corporation (DGC); Date: 1970) **pages 4–5**: @docubyte **page 6**: Photo courtesy of the Arnold del Carlo Collection, Sourisseau Academy for State and Local History, San Jose State University **page 9**: HIP/Art Resource, NY **page 10**: Jim Heimann Collection **page 11 (left)**: Album/Alamy Stock Photo **page 11 (right)**: © Science Museum/Science & Society Picture Library **page 12**: Courtesy of the Computer History Museum (CHM Image #: 102722064; Title: The Univac System; Maker: Remington Rand, Inc.; Date: 1955) **page 13 (left)**: Jim Heimann Collection **page 13 (right)**: Courtesy of International Business Machines Corporation © International Business Machines Corporation **page 14**: Photo by Michael L. Abramson/Getty Images **pages 16–17**: Courtesy of the Computer History Museum (CHM Image #: 102646319; Title: Nihon Tokyo Daigaku Denshi Keisanki Senta University of Tokyo, Japan, Computer Center; Maker: University of Tokyo; Date: 1964) **page 19**: Courtesy of International Business Machines Corporation © International Business Machines Corporation **page 20 (left)**: Courtesy of the Computer History Museum (CHM Image #: 102646201; Title: Univac Scientific at White Sands Missile Range; Maker: Remington Rand Univac; Date: 1953) **page 22 (right)**: Courtesy of the Computer History Museum (CHM Image #: 102646107; Title: H632 General Purpose Digital Computer System; Maker: Honeywell, Inc., Computer Control Division; Date: 1968) **page 23**: Courtesy of International Business Machines Corporation © International Business Machines Corporation **page 24**: Jim Heimann Collection **page 25**: Courtesy of the Computer History Museum (CHM Image #: 102661095; Title: People's Computer Company; Maker: Jim Warren, People's Computer Company; Date: 1972) **page 27 (left)**: © Atari **page 27 (right)**: Courtesy of the Computer History Museum (CHM Image #: 500004131; Title: Atari founders Ted Dabney and Nolan Bushnell with Fred Marincic and Al Alcorn; Date: 1972) **page 28**: Courtesy of the Computer History Museum (CHM Image #: 102646182; Title: Is Software Development Getting You Down?; Maker: Leeco, Inc.; Date: 1981) **page 30**: © LORD **page 31**: American Management Association **pages 32–33**: Courtesy of International Business Machines Corporation © International Business Machines Corporation **page 34 (row 1, number 2)**: Courtesy of the Computer History Museum (CHM Image #: 102646301; Title: The ERA Computation Center for Industry, Government, and Research; Maker: Engineering Research Associates (ERA); Date: 1950) **page 34 (row 4, number 2)**: Courtesy of International Business Machines Corporation © International Business Machines Corporation **page 35 (row 1, number 3; row 2, number 2; row 4, number 2)**: Courtesy of International Business Machines Corporation © International Business Machines Corporation **page 35 (row 3, number 2)**: © Texas Instruments **page 36**: Courtesy of International Business Machines Corporation © International Business Machines Corporation **page 37**: Courtesy of the Computer History Museum (CHM Image #: 102646268; Title: Circle Computer, The Low-Cost General-Purpose Computer for Science and Industry; Maker: Nuclear Development Associates, Inc.; Date: 1953) **page 38**: Courtesy of the Computer History Museum (CHM Image #: 102646230; Title: Bendix G-15; Maker: Bendix Aviation Corporation; Date: 1955) **page 40 (left)**: Courtesy of International Business Machines Corporation © International Business Machines Corporation **page 40 (right)**: Courtesy of the Computer History Museum (CHM Image #: 102646302; Title: Univac II; Maker: Remington Rand Univac; Date: 1957) **page 41**: Courtesy of the Computer History Museum (CHM Image #: 102646271; Title: Elecom "50;" Maker: Underwood Corporation, Electronic Computer Division; Date: 1956) **page 42**: Courtesy of the Computer History Museum (CHM Image #: 102646275; Title: The Bendix G-15 CPM/PERT Program; Maker: Bendix Corporation; Date: 1955) **page 43**: Courtesy of the Computer History Museum (CHM Image #: 102646269; Title: Circle Computer, A General-Purpose Digital Computer for Science and Engineering; Maker: Nuclear Development Associates, Inc.; Date: 1953) **page 44**: Courtesy of International Business Machines Corporation © International Business Machines Corporation **page 46**: Jim Heimann Collection **pages 47, 49–50**: Courtesy of International Business Machines Corporation © International Business Machines Corporation **page 52**: Courtesy of the Computer History Museum (CHM Image #: 102646301; Title: The ERA Computation Center for Industry, Government, and Research; Maker: Engineering Research Associates (ERA); Date: 1950) **page 53**: Courtesy of the Computer History Museum (CHM Image #: 102646144; Title: Bendix G-15 All Purpose Computer; Maker: Bendix Corporation; Date: 1956) **page 54**: Courtesy of the Computer History Museum (CHM Image #: 102646224; Title: Ferranti Mercury; Maker: Ferranti Ltd.; Date: 1956) **page 55**: Courtesy of the Computer History Museum (CHM Image #: 102646280; Title: Bendix G-15 General Purpose Digital Computer; Maker: Bendix Corporation; Date: 1955) **page 57**: Jim Heimann Collection **pages 58–59**: Courtesy of the Computer History Museum (CHM Image #: 102722064; Title: The Univac System; Maker: Remington Rand, Inc.; Date: 1955) **page 60**: Courtesy of the Computer History Museum (CHM Image #: 102646140; Title: Introducing A New Language for Automatic Programming, Univac Flow-Matic; Maker: Sperry Rand Corporation, Univac Data Processing Division; Date: 1957) **pages 61–62**: Courtesy of International Business Machines Corporation © International Business Machines Corporation **page 63**: Courtesy of the Computer History Museum (CHM

Image #: 102646112; Title: The Univac Data Communications System; Maker: Sperry Rand Corporation, Univac Data Processing Division; Date: 1957) **page 64**: Courtesy of the Computer History Museum (CHM Image #: 102646227; Title: Univac Solid-State Computer . . . A Major Breakthrough for Business-America; Maker: Remington Rand Univac; Date: 1958) **pages 65–66**: Jim Heimann Collection **page 67**: Courtesy of the Computer History Museum (CHM Image #: 102646210; Title: Remington Rand Univac 120; Maker: Remington Rand Univac Division of Sperry Rand Corporation; Date: 1956) **page 68**: Courtesy of the Computer History Museum (CHM Image #: 102646083; Title: Stantec Zebra Electronic Digital Computer; Maker: Standard Telephones and Cables Limited, London (STC); Date: 1957) **page 69**: Courtesy of International Business Machines Corporation © International Business Machines Corporation **page 71**: © NCR **pages 73–75**: Courtesy of International Business Machines Corporation © International Business Machines Corporation **page 76 (row 1, number 1)**: Courtesy of the Computer History Museum (CHM Image #: 102646097; Title: Programmed Data Processor-1; Maker: Digital Equipment Corporation (DEC); Date: 1961) **page 76 (row 1, number 3; row 3, number 3)**: Courtesy of International Business Machines Corporation © International Business Machines Corporation **page 76 (row 4, number 3)**: Courtesy of the Computer History Museum (CHM Image #: 102646121; Title: BASIC (Now YOU Can Program . . .); Maker: General Electric Company (GE); Date: 1965) **page 77 (row 1, number 3)**: © Georges Pierre **page 77 (row 2, number 2)**: © HP **page 77 (row 3, number 2)**: © Intel **page 77 (row 4, number 2)**: © NASA **page 78**: Courtesy of the Computer History Museum (CHM Image #: 102646241; Title: On-Line Saving Systems Featuring the NCR 315; Maker: National Cash Register Company (NCR); Date: 1960) **page 79**: Courtesy of the Computer History Museum (CHM Image #: 500004829; Title: Shockley Four-Layer Diode; Maker: Clevite Transistor; Date: ca. 1960) **page 80**: Courtesy of the Computer History Museum (CHM Image #: 102646237; Title: RCA Spectra 70, Data Gathering System; Maker: RCA Corporation Information Systems; Date: 1968) **pages 82–83**: Courtesy of International Business Machines Corporation © International Business Machines Corporation **page 85**: Jim Heimann Collection **page 86**: Courtesy of the Computer History Museum (CHM Image #: 102646137; Title: The HYCOMP Hybrid Analog/Digital Computing System; Maker: Packard Bell Electronics, Packard Bell Computer; Date: 1964) **page 87**: Courtesy of International Business Machines Corporation © International Business Machines Corporation **page 88**: Courtesy of the Computer History Museum (CHM Image #: 102646090; Title: Operating System Orientation for Management; Maker: Honeywell Information Systems, Inc.; Date: 1966) **page 89**: Courtesy of the Computer History Museum (CHM Image #: 102646097; Title: Programmed Data Processor-1; Maker: Digital Equipment Corporation (DEC); Date: 1961) **page 90**: Courtesy of the Computer History Museum (CHM Image #: 102646242; Title: NCR 315 CRAM File; Maker, National Cash Register Company (NCR); Date: 1962) **page 92**:

Courtesy of International Business Machines Corporation © International Business Machines Corporation **pages 93–94**: Courtesy of the Computer History Museum (CHM Image #: 102646159; Title: For the Time Sharing Computer User, Datapoint 3300; Maker: Computer Terminal Corporation (CTC); Date: 1969) **page 95**: Courtesy of the Computer History Museum (CHM Image #: 102660789; Title: RCA Spectra 70/45 Computer; Maker: Radio Corporation of America (RCA); Date: 1966) **pages 96–97**: Courtesy of the Computer History Museum (CHM Image #: 102646105; Title: UNIVAC 1108-II, The Big System with the Big Reputation; Maker: Sperry Rand Corporation, Univac Data Processing Division; Date: 1965) **page 101**: Courtesy of the Computer History Museum (CHM Image #: 102646157; Title: H316 General Purpose Digital Computer; Maker: Honeywell, Inc. Computer Control Division; Date: 1965) **page 102**: Courtesy of the Computer History Museum (CHM Image #: 102646283; Title: Molecular Electronic Computer; Maker: Texas Instruments, Inc. (TI); Date: 1961) **page 103**: Courtesy of the Computer History Museum (CHM Image #: 102646240; Title: NCR CRAM: Card Random Access Memory; Maker: National Cash Register Company (NCR); Date: 1960) **page 104**: Courtesy of International Business Machines Corporation © International Business Machines Corporation **page 105**: Courtesy of the Computer History Museum (CHM Image #: 102646105; Title: Univac 1108-II, The Big System with the Big Reputation; Maker: Sperry Rand Corporation, Univac Data Processing Division; Date: 1965) **page 108**: Courtesy of the Computer History Museum (CHM Image #: 102646294; Title: New TEC Lite Data Panel; Maker: Transister Electronics Corporation; Date: 1964) **page 109**: Courtesy of the Computer History Museum (CHM Image #: 102646107; Title: H632 General Purpose Digital Computer System; Maker: Honeywell, Inc. Computer Control Division; Date: 1968) **page 112**: Courtesy of the Computer History Museum (CHM Image #: 102646229; Title: Burroughs B2500 and B3500 Electronic Data Processing Systems, A New Level of Computer Responsiveness; Maker: Burroughs Corporation; Date: 1966) **pages 114–115**: Courtesy of the Computer History Museum (CHM Image#: 102646106; Title: Univac 9400 Computer; Maker: Sperry Rand Corporation, Univac Data Processing Division; Date: ca. 1969) **page 116**: Courtesy of the Computer History Museum (CHM Image #: 102646218; Title: TR-24, TR-48 Desk Top Analog Computers . . . for the Ultimate in High-Speed, Low-Cost Problem Solving Capabilities; Maker: Electronic Associates, Inc. (EAI); Date: 1964) **page 118**: Courtesy of the Computer History Museum (CHM Image #: 102646222; Title: International Computers and Tabulators LTD.; Maker: International Computers and Tabulators, Limited (ICT); Date: 1964) **page 119**: Courtesy of the Computer History Museum (CHM Image #: 102646234; Title: Ferranti Argus Process-Control Computer System; Maker: Ferranti Ltd.; Date: 1961) **page 120**: Courtesy of the Computer History Museum (CHM Image #: 102646248; Title: Ferranti Orion Computer System; Maker: Ferranti Ltd.; Date: 1960) **page 123**: Courtesy of the Computer History Museum (CHM Image #: 102621688; Title: Presenting A Totally Different

CREDITS CONT.

Concept in Electronic Data Processing, Series 900 EDP System; Maker: Addressograph-Multigraph Corporation; Date: ca. 1961) **page 124**: Courtesy of International Business Machines Corporation © International Business Machines Corporation **page 125**: Courtesy of the Computer History Museum (CHM Image #: 102646078; Title: HITAC 10: High Performance Mini Computer; Maker: Hitachi, Ltd.; Date: 1969) **pages 126–127**: Bob Marsh **page 128 (row 1, number 1)**: Courtesy Stanford **page 128 (row 1, number 2; row 3, number 1)**: © Atari **page 128 (row 1, number 3)**: Intel C4004 by Thomas Nguyen, CC BY-SA 4.0, background removed **page 128 (row 3, number 2)**: Evan Amos **page 128 (row 4, number 3)**: Ted Nelson **page 129 (row 1, number 2)**: Lee Felsenstein **page 129 (row 2, number 1)**: © Microsoft **page 129 (row 2, number 3)**: © Science Museum/Science & Society Picture Library **page 129 (row 3, number 3; row 4, number 1)**: Division of Medicine and Science, National Museum of American History, Smithsonian Institution **page 129 (row 4, number 3)**: Evan Amos **pages 130–131**: Lou Brooks **page 132**: Courtesy of the Computer History Museum (CHM Image #: 102646254; Title: Tektronix 4051, New Low-Cost Basic Graphic Computing System; Maker: Tektronix, Inc.; Date: 1976) **page 133**: Courtesy of the Computer History Museum (CHM Image #: 102646165; Title: Hewlett Packard 2100 Processor Description; Maker: Hewlett-Packard Company (HP); Date: 1972) **page 134**: Courtesy of the Computer History Museum (CHM Image #: 102646206; Title: HP 9701A/B Distributed Systems; Maker: Hewlett-Packard Company (HP); Date: 1973) **page 135**: Courtesy of the Computer History Museum (CHM Image #: 102646151; Title: MAC 16; Maker: Lockheed Electronics Company, Inc.; Date: 1970) **page 138**: Courtesy of the Computer History Museum (CHM Image #: 102641285; Title: The Expanding World of TRS-80; Maker: Tandy Radio Shack Corporation (TRS); Date: 1979) **page 139**: Courtesy of the Computer History Museum (CHM Image #: 102646108; Title: Radio Shack TRS-80 Model I; Maker: Tandy Radio Shack Corporation (TRS); Date: 1977) **page 140**: Courtesy of the Computer History Museum (CHM Image #: 102646154; Title: Fox 1 Software, Fastware; Maker: Foxboro; Date: 1971) **page 141**: Courtesy of the Computer History Museum (CHM Image #: 102646110; Title: CIP/4000 A Midi Designed For Process Control; Maker: Cincinnati Milacron, Inc.; Date: 1970) **page 142**: Courtesy of the Computer History Museum (CHM Image #: 102646128; Title: PDP-11 Resource Timesharing System, RSTS-11; Maker: Digital Equipment Corporation (DEC); Date: 1970) **page 143**: Courtesy of the Computer History Museum (CHM Image #: 102646153; Title: Nova, Super Nova; Maker: Data General Corporation (DGC); Date: 1970) **page 145**: Courtesy of the Computer History Museum (CHM Image #: 102646111; Title: Naked Mini/Alpha 16; Maker: Computer Automation, Inc.; Date: 1972) **page 146**: Courtesy of the Computer History Museum (CHM Image #: 102641283; Title: Net/Alert: Because You Shouldn't Learn About Your IP Network Problems from Your Users; Maker: Avant-Garde Computing, Inc.; Date: 1970–1979) **page 148**: Courtesy of the Computer History Museum (CHM Image #: 102646129; Title: System IV/70: the Data-Base Access System of the '70s; Maker: Four-Phase Systems, Inc.; Date: 1970) **page 149**: Courtesy of the Computer History Museum (CHM Image #: 102646156; Title: Sperry Univac Series V77 Mini-computer Systems, Power, Performance, Productivity; Maker: Sperry Rand Corporation, Univac Data Processing Division; Date: ca. 1978) **page 152**: Courtesy of the Computer History Museum (CHM Image #: 102646315; Title: Super Bee: A Micro Programmable Terminal from The House of Beehive; Maker: Beehive International; Date: 1978) **page 153**: Courtesy of the Computer History Museum (CHM Image #: 102641282; Title: We've Got the First Low-Priced Big Screen; Maker: Tektronix, Inc.; Date: 1974) **page 154**: Courtesy of International Business Machines Corporation © International Business Machines Corporation **page 155**: © Xerox Corporation **pages 158–159**: Courtesy of the Computer History Museum (CHM Image #: 102646187; Title: Atari Home Computers: The Next Generation; Maker: Atari, Inc.; Date: 1983) **page 160 (row 1, number 1)**: HP85A by Thomas Schanz, CC BY-SA 4.0, background removed and straightened **page 160 (row 2, number 2)**: Evan Amos **page 160 (row 4, number 1)**: Time Inc. **page 160 (row 4, number 2)**: Macintosh by Danamania, CC BY-SA 2.5, background removed **page 161 (row 1, number 2)**: Evan Amos **page 161 (row 1, number 3)**: Peter Kleeman/Space Age Museum **page 161 (row 2, number 3)**: Atari XEGS by Bilby, CC BY 3.0 **page 161 (row 3, number 1)**: IBM PS/2 by Raymangold22, CC0 1.0 **page 162**: Courtesy of the Computer History Museum (CHM Image #: 102646183; Title: The CRAY X-MP Series of Computer Systems; Maker: Cray Research, Inc. (CRI); Date: 1985) **page 163**: Courtesy of the Computer History Museum (CHM Image#: 102646185; Title: Cray-2; Maker: Cray Research, Inc. (CRI); Date: 1985) **page 167**: © HP **pages 172–173**: © Tandy **page 176**: © Texas Instruments **page 177**: © Olivetti **page 178**: © Xerox Corporation **page 180**: © Texas Instruments **page 183**: © Amherst IDA **page 187**: © Tandy **page 188**: © Maxell **pages 189, 192**: © Atari **pages 193–194**: © Mattel **pages 195, 197**: © Atari **page 200**: © Tandy **pages 202–203**: © Minolta **page 204 (row 1, number 3)**: Steven Stengel/oldcomputers.net **page 204 (row 2, number 3)**: © Wired **page 204 (row 4, number 1)**: Evan Amos **page 204 (row 4, number 2)**: © Amazon **page 205 (row 2, number 2)**: © Time Inc. **page 206, 207** Jim Heimann Collection **page 208**: © Microsoft **page 210**: © Adobe **page 211**: Jim Heimann Collection **page 212**: © Nintendo **page 213**: © Microsoft **page 214**: © Sony **page 215**: © Intel **page 216**: © Adobe **page 217**: © Microsoft **page 218**: © Intel **page 221**: Jim Heimann Collection **pages 222–223**: © Microsoft **page 224**: Jim Heimann Collection **page 225**: © Sony **page 226 (left)**: © Microsoft **page 227**: Courtesy of International Business Machines Corporation © International Business Machines Corporation **pages 228–229**: Photo courtesy of the Arnold del Carlo Collection, Sourisseau Academy for State and Local History, San Jose State University **pages 236–239**: @docubyte **page 240**: Courtesy of the Computer History Museum (CHM Image #: 102646090; Title: Operating System Orientation for Management; Maker: Honeywell Information Systems, Inc.; Date: 1966)

ACKNOWLEDGMENTS

First and foremost, a mainframe-sized thank you goes out to Jim Heimann for providing me with wisdom and encouragement over the course of this journey that began in 2014; for teaching me everything he knows about books, design, and illustration; for instilling in me his own keen eye and passion for ephemera; for being a patient and generous mentor; and, most of all, for his friendship over the last 11 years. This book is dedicated to him.

Thank you to my collaborators: J.C. Gabel, the maestro and publisher behind Hat & Beard Press, was one of the first people I told about this project, and he was wholeheartedly onboard from the get-go. Unwavering in his support and enthusiasm, his involvement ultimately allowed this idea to blossom into something far greater than I had anticipated; Steven Heller, whose body of work (specifically his numerous books on graphic design and column for *Print* magazine) have provided me with an endless well of inspiration over the years. His knowledge and expertise within the realms of advertising and graphic design is nonpareil and I am honored that he agreed to contribute his words to this book; and John Zabawa, a true artist whose ideas about what the cover should be were a breath of fresh air. His brilliant, singular eye and aesthetic helped elevate this book to new heights, and he was a pleasure to work with from start to finish.

Thank you to the Computer History Museum, which proved to be an indispensable resource. An extra special thanks goes out to Senior Archives Manager Sara Lott for her patience in guiding me through the nuances of the museum's extensive collections.

Last, but not least, a thank you goes out to the following people who helped make this possible: James Ball, Lou Brooks, Jonathan Castellanos, Perry Chen, K.K. Davis, Lee Felsenstein, Joyce Fowler, Linda Foshee, Sue Greco, Meg Handler, Jaime Haver, George Helfand, Kim Hicks, Marteinn Jonasson, Leilani Marshall, Forest McMullin, Jim Mungia, Kenton Nelson, A.J. Palmgren, Sybil Perez, Massimo Petrozzi, Sam Rader, Ken Segall, Dag Spicer, Laura Stafford, Cindy Vance, and Jonathan Zufi.

Edited by Ryan Mungia and J.C. Gabel
Art directed and designed by Ryan Mungia
Cover artwork and design by John Zabawa
Copy edited by Sybil Perez

Introduction © Steven Heller
Selling Tech © Ryan Mungia

© 2019 Hat & Beard Press
© 2019 Boyo Press

www.hatandbeard.com
www.boyopress.com

ISBN 978-0-9916198-2-5

Printed in Bosnia and Herzegovina

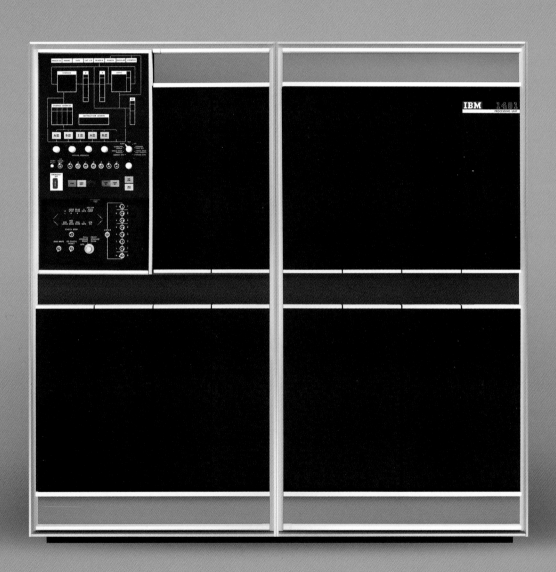

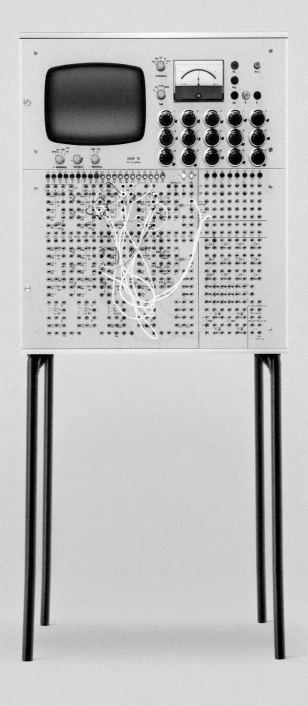

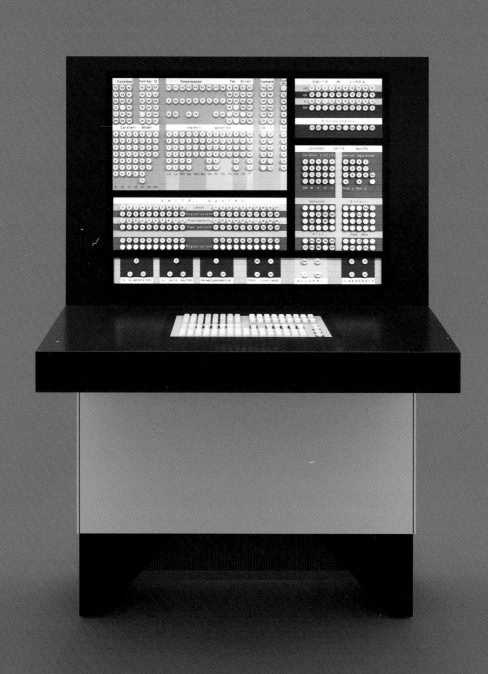

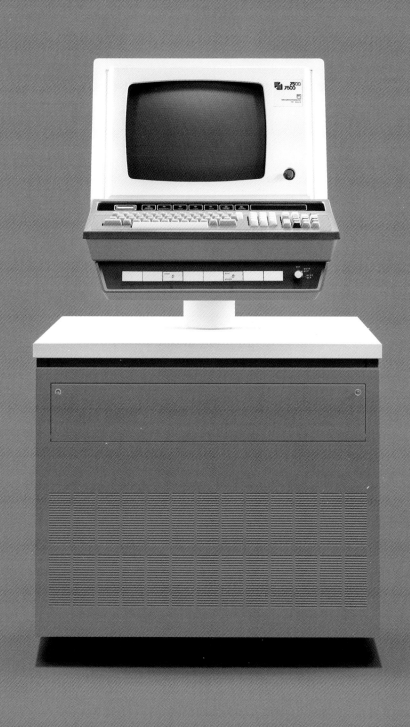

Structure of an
Operating System